THE GREAT RAILWAY STATIONS OF PARIS

MICHAEL PATTERSON

AMBERLEY

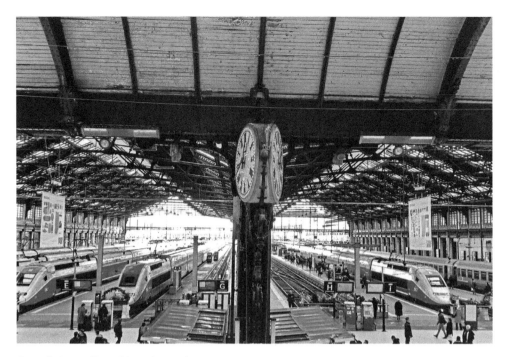

Gare de Lyon. (Pascal Poggi, 2014)

First published 2017

Amberley Publishing
The Hill, Stroud
Gloucestershire, GL5 4EP

www.amberley-books.com

Copyright © Michael Patterson, 2017

The right of Michael Patterson to be identified
as the Author of this work has been asserted in
accordance with the Copyrights, Designs and
Patents Act 1988.

ISBN 978 1 4456 6920 5 (print)
ISBN 978 1 4456 6921 2 (ebook)

British Library Cataloguing in Publication Data.
A catalogue record for this book is available from
the British Library.

Typesetting by Amberley Publishing.
Printed in the UK.

Introduction

On 24 August 1837, the wife of King Louis-Philippe of France opened a railway station close to the Place de l'Europe in the north-west of Paris, marking the arrival of railways in the French capital. Referred to variously as the Europe platform or West platform, the station was the Paris terminus of a short line to Le Pecq, about 18 kilometres west of the capital. This temporary wooden structure was the forerunner of Saint-Lazare station and the other great railway stations of Paris.

The early Paris termini built by the fledgling railway companies of France were known as *embarcadères*, meaning place of embarkation or embarkation platform. The embarcadère de l'Europe was followed in 1840 by the embarcadère de la barrière du Maine (now Montparnasse station), the embarcadère d'Orléans (Austerlitz station), and in 1846 by the embarcadère du Nord (Gare du Nord). The Gare de Lyon opened in 1847, the embarcadère de Strasbourg (now the Gare de l'Est) in 1849 and finally in this first wave the Gare de Vincennes (also known as the Gare de la Bastille) in 1859.

A number of the companies sought to extend their lines into the heart of Paris but their ambitions were thwarted by the city authorities, backed up by resistance from property owners along their intended routes. So, with no prospect of a central station serving a number of companies' lines, the various termini formed a ring around the centre of Paris and were eventually linked together by a railway known as the *Petite Ceinture*, meaning little belt, itself now largely abandoned or adapted for alternative transport uses.

In 1851 a coup d'état brought Emperor Napoleon III to the throne. The period of his reign is known as the Second Empire, a time of grand schemes and great ambitions. He appointed Baron Haussmann to rebuild Paris and between 1858 and 1870 broad avenues were driven through the heart of the city. The efficient distribution of passengers to and from the main railway termini was a key concern, so the stations became nodal points in the new road network. The growth in passenger traffic also meant that many of the termini had to be redeveloped during this period and the railway companies vied with each other to build ever larger and more magnificent stations worthy of the Second Empire.

The layout of the early stations generally followed a simple pattern – on one side of the station there were facilities and platforms for departures; on the other side, the same for arrivals. This proved to be a rather inflexible arrangement and the fact that suburban trains sometimes used the same tracks and platforms as main-line trains added to the operational difficulties. Only when the boom in passenger traffic led to the stations being enlarged were long distance and suburban trains given their own tracks and platforms, and the system of separate arrival and departure sides was eventually abandoned. Some of the larger termini now acquired a *salle des pas perdus*, literally meaning 'hall of lost footsteps'. These were vast enclosed spaces leading to ticket offices and other facilities and were the focal point of the station. Those that survive have mostly been transformed into shopping malls.

The Franco-Prussian war of 1870 saw massive movements of French troops and supplies from the Gare de l'Est to the front in eastern France. A series of swift victories by the German forces resulted in the capture of Napoleon III and the downfall of the Second Empire. The Germans then laid siege to Paris, during which the train shed at the Gare d'Orléans (Austerlitz) was converted into a workshop for making giant gas balloons to convey mail over the siege lines. After Paris fell in January 1871, a revolutionary uprising called the Paris Commune seized power in the capital and held it for two months before being bloodily put down. During the Commune, the Gare Montparnasse was wrecked and the Gare de Lyon partly burnt down.

An enormous upsurge in the population of Paris during the nineteenth and twentieth centuries brought rapid growth of the suburbs and a huge increase in commuting to the major rail termini. Between 1801 and 1881, the population of Paris grew by 134 per cent – nearly four times as fast as in France as a whole. This trend continued into the twentieth century, the annual movement of travellers in Paris rising to 400 million by 1930, with up to 450,000 arriving daily from the suburbs. To cater for these numbers, the major termini had repeatedly to be enlarged. For example, the number of platforms at the Gare du Nord increased from eight in 1865, first to thirteen, then to eighteen and finally to twenty-eight in 1900, while the Gare de l'Est almost doubled in size to thirty platforms between 1900 and 1931.

The great stations of Paris played a key role in both world wars of the twentieth century. On the outbreak of the First World War in 1914, the Gare de l'Est was once again the station where troops were mobilised and dispatched to the front. Meanwhile the Gare du Nord received 1.5 million refugees fleeing the German invasion of Belgium and northern France in the first few weeks of the war. Both stations continued to play a pivotal role in linking the capital to the trenches of the Western Front. During the Second World War both Est and Nord stations were heavily used for war purposes by the occupying German army and in 1944 the German surrender of Paris took place at the Gare Montparnasse.

Although some small French railway companies were brought under state control as early as 1878 under the aegis of the Chemins de Fer de l'Etat (literally 'State Railways') and the much larger Compagnie de l'Ouest was absorbed in 1908, the bulk of the French railway system remained in private hands until it was nationalised in 1938 under the control of the Société Nationale des Chemins de Fer Français

(SNCF). Modernisation of the rail network had already begun in the inter-war years with third-rail electrification of suburban lines serving Saint-Lazare while other electrification projects eliminated main-line steam operations from Austerlitz and Montparnasse. The post-war era saw electrification of much of the network, the last steam trains in Paris finally being phased out from the Gare du Nord in 1970. At the same time, the first rapid-transit cross-city lines, the Réseau Express Régional (RER), began to come on stream, taking over many of the suburban routes serving the Paris termini.

Some of the great trains of the 'golden age' of railways started or ended their journeys in Paris – Orient Express, Nord-Express, Night Ferry, Flèche d'Or, Mistral and Train Bleu are just a few of the famous names long since erased from railway timetables. As late as the 1990s, dozens of traditional sleeping-cars still departed nightly from Paris for destinations across Europe including Moscow, Warsaw, Copenhagen, Vienna, Rome and Madrid. Today hardly any remain. The post-war era of luxury first-class-only Trans-Europ-Expresses with their classic restaurant cars gave way to the two-class EuroCity concept, but they all fell victim to low-cost airlines and above all to the high-speed revolution brought about by Trains à Grande Vitesse (TGVs) on a network of brand new lines, slashing journey times and greatly increasing frequency. TGV services now fan out from Montparnasse, Lyon, Nord and Est stations, with more lines planned. Long-distance routes without TGVs are today served by Intercity (Intercité) trains. TER (Transport Express Régional) services operate from the Paris termini out to the neighbouring regions while Paris suburban services operate under the Transilien brand name.

A skyscraper now stands on the site of the old Gare Montparnasse and a modern station has been built to replace it, but the great nineteenth-century stations of Austerlitz, Est, Lyon, Nord and Saint-Lazare have been adapted and modernised to cater for the new railway age. Through the words and images in this book, I hope the reader will share some of my enthusiasm for the history and architecture of the great railway stations of Paris and the vital role they continue to play in the twenty-first century.

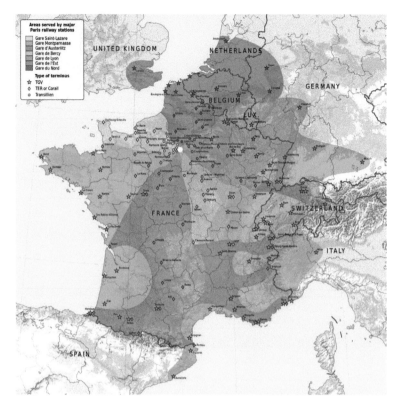

The parts of France and neighbouring countries served by each Paris terminus. (Sémhur / Wikimedia Commons / CC-BY-SA-3.0 *)

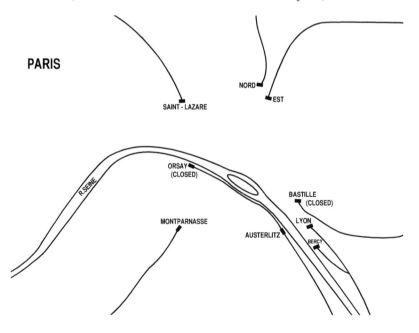

Sketch map of Paris showing the location of stations featured in this book.

Gare Saint-Lazare

Opened in August 1837 by Marie-Amélie, wife of King Louis-Philippe, the first railway terminus in Paris was located a short distance to the north-west of the present Gare Saint-Lazare. A temporary wooden structure, the embarcadère de l'Europe (Europe platform or West platform as it was sometimes known), was at the end of a line from Le Pecq, 18 kilometres west of Paris. A more substantial building was constructed in 1841 but again this was only a temporary structure while the Paris-St Germain Railway Company sought to extend its line into the heart of the capital – a plan ultimately thwarted by the city authorities and opposition by property owners on the projected route.

A third station was constructed between 1842 and 1853, this time 200 metres to the south on the rue Saint-Lazare, from which the station takes its name. In 1855 the Paris-St Germain company became part of the newly formed Compagnie des Chemins de Fer de l'Ouest (Western Railway Company). A large extension to the station opened in 1867 to cope with the growing number of passengers, which had by now reached 25 million a year.

The present Gare Saint-Lazare was constructed between 1886 and 1889 to a design by the architect Juste Lisch, although the earlier train sheds engineered by Eugène Flachat were retained. There were twenty-two platforms, of which eight were for main-line services, and the number of tracks approaching the station was increased from four to six.

Two incidents stand out in the history of Saint-Lazare during the early part of the twentieth century. In January 1908, frozen points and signals brought services to a standstill after weeks of problems. Frustrated commuters rioted, breaking windows, ripping out seats and attacking railway staff before the police could restore order. Then, in 1921, a train accident killed twenty-eight passengers when they were trapped in a fire in one of the tunnels on the approaches to the station. This led to the demolition of three tunnels, allowing a further increase in the number of approach tracks.

Electrification of suburban routes from Saint-Lazare began in 1924 and continued until the mid-1930s. A third-rail system was chosen, bringing greater operational flexibility compared with steam traction as well as a cleaner travelling environment for

passengers. At the same time, major improvements were made to passenger facilities in order to cope with the continuing growth in passenger numbers, notably the inauguration of a new *salle des pas perdus* (passenger hall) in 1930.

Steam operation continued on some routes until the 1960s. From 1966, overhead electrification was progressively installed on all main-line and suburban routes to replace third-rail and diesel operation. The opening of the first stage of the rapid-transit cross-Paris Regional Express network (RER) brought major changes. The historic route to Le Pecq and Saint-Germain was integrated into RER Line A in 1972 and other suburban routes followed in the 1970s and 1980s.

With twenty-seven platforms, the station handles 450,000 passengers a day and is the second-busiest in Paris after the Gare du Nord. In the rush hours a train arrives at or departs from Saint-Lazare every 28 seconds on average and in 2015 the station had over 105 million passenger journeys. Although it has not enjoyed the kind of investment which construction of the high-speed TGV network has brought to most other Paris termini, between 2009 and 2012 Saint-Lazare did see some major improvements including easier connections with the Metro. Meanwhile the old passenger hall has been transformed into a spectacular three-level shopping mall.

While Saint-Lazare is primarily a commuter station, it also served as the Paris terminus for trains connecting with transatlantic shipping routes at Le Havre and Cherbourg, notably for sailings to New York. Regular services came to an end when the liner *France* was withdrawn in 1974. Boat trains to Dieppe for ferries to England continued to operate until the Channel Tunnel opened in 1994.

Saint-Lazare station has been represented in a number of works of art. It attracted writers such as Emile Zola and artists of the Impressionist period such as Édouard Manet and Claude Monet, some of whom lived close to the station in the 1870s and 1880s. Monet introduced himself to the station staff as 'Monsieur Monet the painter', although as an artist he was relatively unknown at the time. Nevertheless he was accorded great respect, becoming a familiar figure at the station, and was even asked if he would like the trains shunted round for better artistic effect.

Today, the Gare Saint-Lazare is served by long-distance Intercity trains to Normandy including Rouen, Le Havre, Caen, Cherbourg and Dieppe while regional and suburban trains serve places west of Paris.

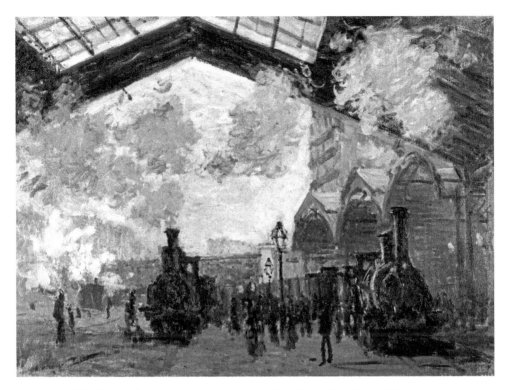

Gare Saint-Lazare in 1877 – one of several such paintings by Claude Monet.

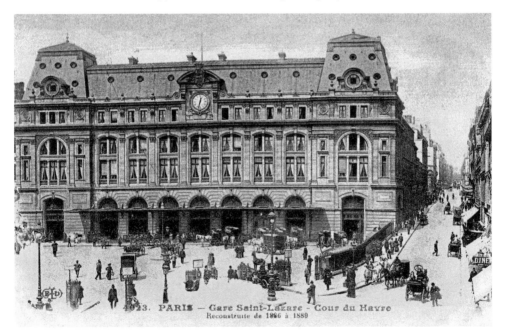

A postcard showing Saint-Lazare in the early twentieth century. The card has an interesting history – it was posted from the station in 1917 to a soldier serving with the Belgian Army on the Western Front. (Author's collection)

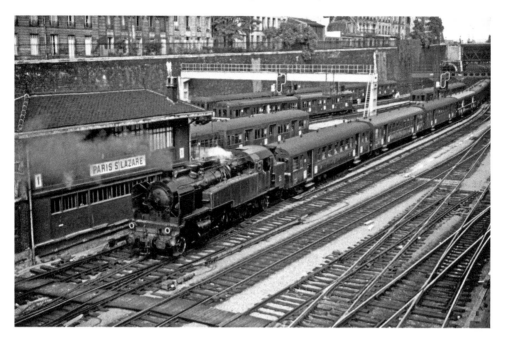

Steam at Saint-Lazare – a Class 141TD locomotive propelling its train out of the station. (John Cosford, 1964)

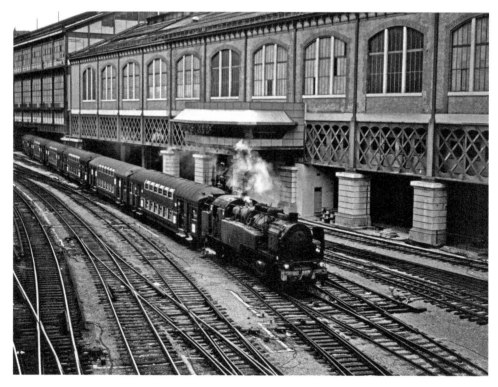

Another locomotive of the same class entering the station with a train of double-deck stock. (John Cosford, 1965)

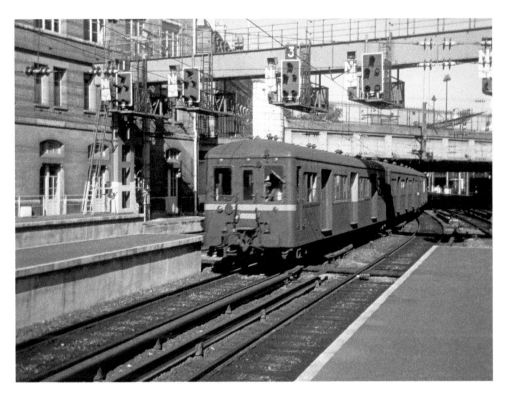

A train of 'Standard' third-rail suburban units arriving at Saint-Lazare in 1976. (Didier Duforest)

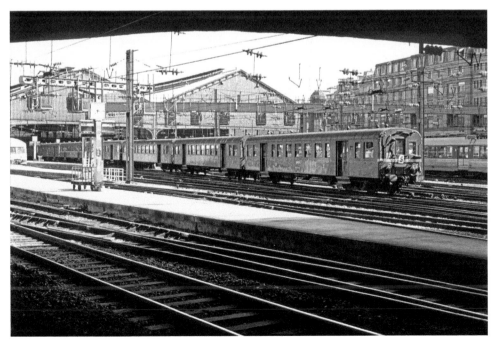

A train of 'Talbot' suburban units leaving in 1981. (Didier Duforest)

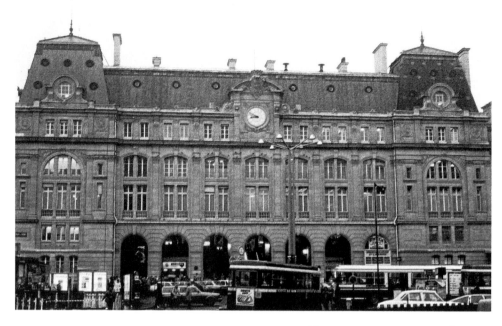

Above: Bus congestion outside Saint-Lazare in 1982. (Author)

Left: The gable end and distinctive 'lighthouse' feature of the train shed. (Author, 1982)

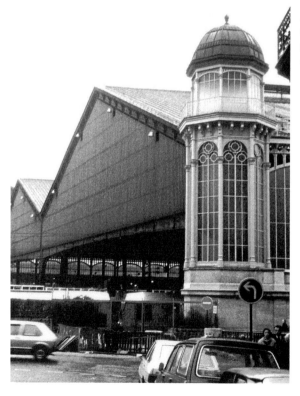

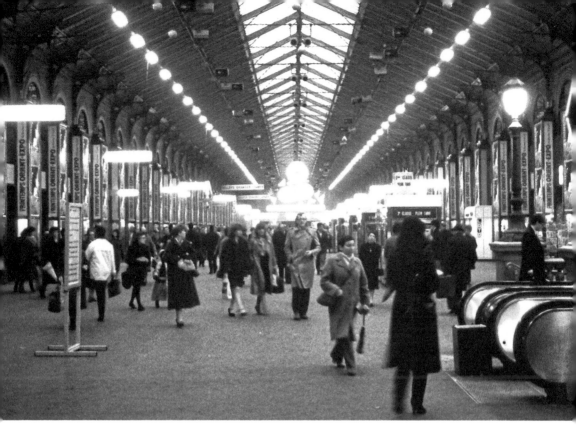

Morning rush hour at Saint-Lazare, 1982. (Author)

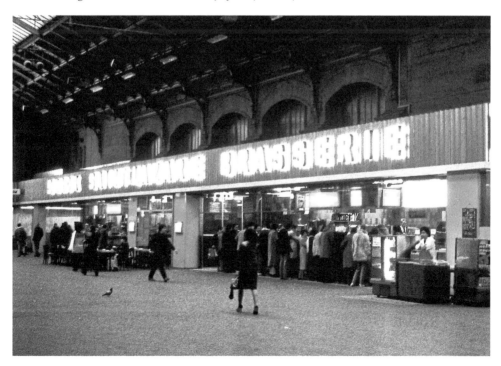

Brisk trade at the brasserie and bar. (Author, 1982)

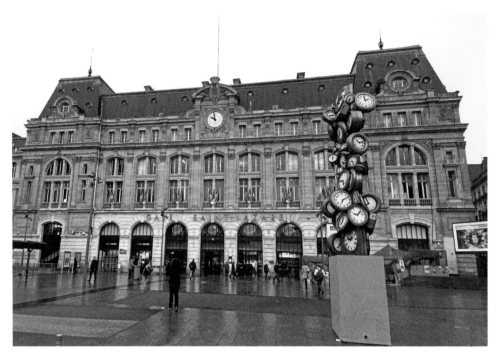

The frontage and pedestrianised forecourt of Saint-Lazare in 2014. The clock sculpture was designed by the artist Arman in 1985 and is called *L'Heure de Tous* (*Everyone's Time*). All the clocks show a different time so in theory you are never late for your train! (Jorge Láscar)

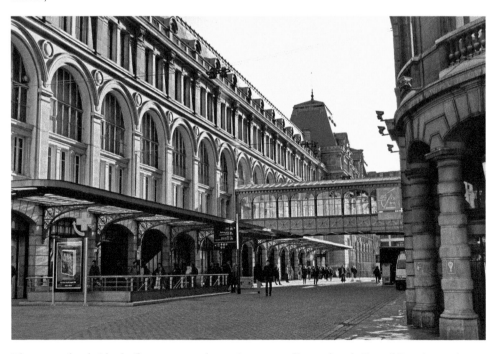

The ornate footbridge built to connect the station to an adjacent hotel. (Pascal Poggi, 2014)

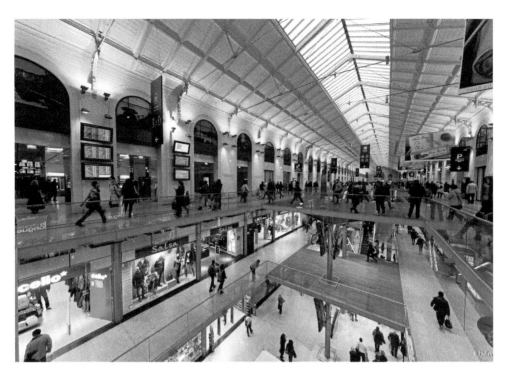

The vast *salle des pas perdus* (passenger hall) has been converted into a three-level shopping mall with passenger facilities on the top floor. (Philippe Clabots, 2014)

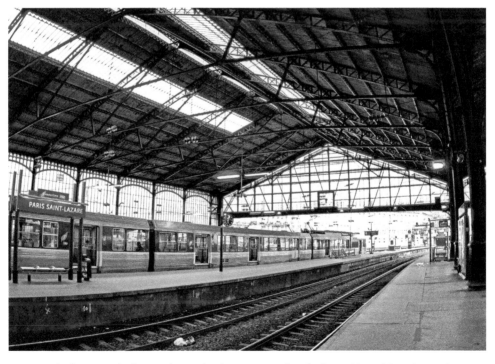

Inside the train shed, a modern suburban train at the platform. (Pascal Poggi, 2012)

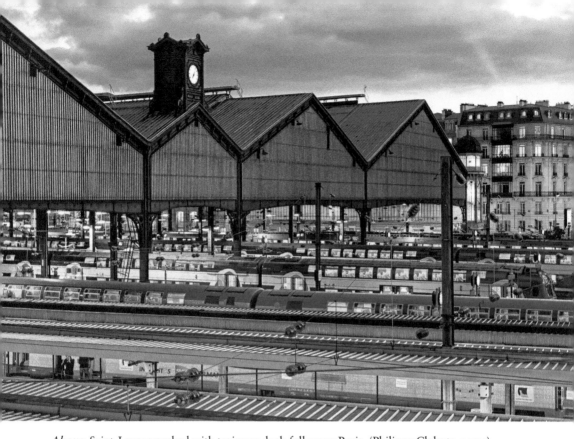

Above: Saint-Lazare packed with trains as dusk falls over Paris. (Philippe Clabots, 2014)

Below: The evening rush hour beneath the gable ends of the train shed roof. (Philippe Clabots, 2014)

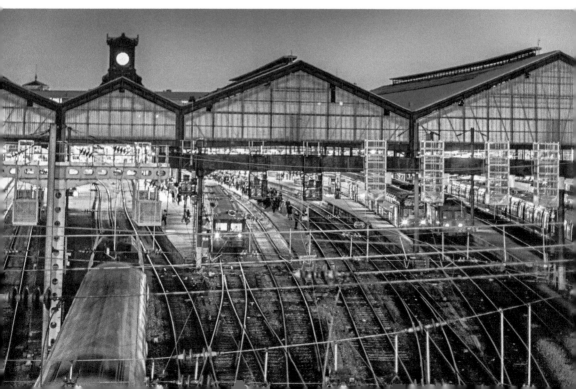

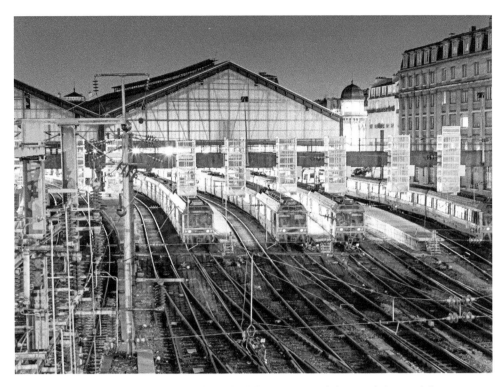

A line-up of suburban trains at the end of the evening rush hour. (Philippe Clabots, 2014)

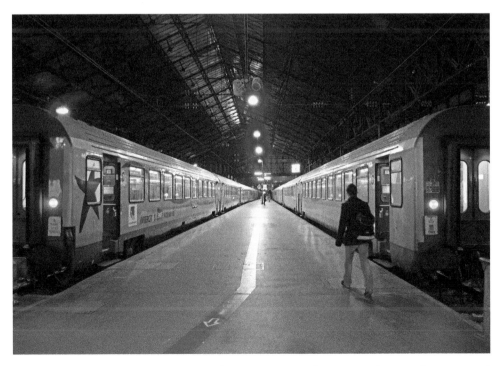

Intercity trains waiting to depart with evening services for Normandy. (Pascal Poggi, 2012)

Gare Montparnasse

The first station at Montparnasse was opened in 1840 by the Paris-Versailles Railway Company. Originally called embarcadère de la barrière du Maine (platform of the Maine barrier), it was situated in the district of Montparnasse on the left bank of the Seine. With just two platforms in an iron train shed, the station quickly became too small to cope with demand and was rebuilt on a larger scale between 1850 and 1852. Designed by architect Victor Lenoir and engineered by Eugène Flachat in neoclassical style, the new station became a principal terminus for the Compagnie des Chemins de Fer de l'Ouest (Western Railway Company). It was built as a twin-sided station with arrivals and departures taking place on separate platforms on opposite sides of the station. This somewhat inflexible approach – common in the mid-nineteenth century – eventually led to capacity problems. The defining features of the station's symmetrical frontage were the massive twin arched windows reflecting the structure of the train shed behind.

Montparnasse station had to be restored after being wrecked during the Paris Commune uprising of 1871. In 1895 it made news around the world when an express train from Granville overran the buffer stops, careered across the station concourse and out of the station, plummeting on to the street below where the locomotive ended up on its nose. Miraculously, the only fatality was a woman outside the station who was killed by falling masonry. The accident was caused by a faulty brake; the engine driver had been speeding to make up lost time.

The Western Railway Company was absorbed by the Chemins de Fer de l'État (French state railways) in 1908. After the First World War, work began on doubling capacity at Montparnasse by the construction of a new station on the Place du Maine. Several hundred metres down the line from the old Montparnasse station, the Gare du Maine, as it became known, was designed in art deco style by Henri Pacon. Long-distance trains began using the new station after the main line to Le Mans was electrified in 1937, leaving the relatively short platforms of the old Montparnasse for use by suburban services.

During the Second World War, Paris was occupied by the forces of the Third Reich. On 25 August 1944, the German military governor of Paris, General von Choltitz,

surrendered his garrison to the French General Philippe Leclerc at Montparnasse station after disobeying Hitler's direct order to destroy the city.

In the 1960s the Maine-Montparnasse area became part of a major programme of urban renewal. A new Gare Montparnasse, integrated into a vast complex of office buildings and high-rise apartments, was built on the site of the Gare du Maine. This allowed the original Montparnasse station to be demolished in 1969 and the Montparnasse Tower skyscraper now stands on the site. The design of the new station has been condemned as a faceless, featureless block replacing a terminus full of character, but in reality the old station could never have coped with modern demands and its fate was far from unique among Europe's great railway termini in the post-war era.

An extension to the station was built in 1990 to accommodate the new high-speed TGV Atlantique services to west and south-west France. Montparnasse station was given a new glass frontage and the interior was remodelled. A raft was constructed over the platforms so that they are no longer visible from the outside. The space above the raft is used for car parking with the level above that converted into a large new public garden, the Jardin Atlantique.

The scale of the passenger facilities at Montparnasse is impressive but they can be confusing to the uninitiated. The station complex sprawls over a vast area and is divided into three zones: Montparnasse I (Porte Océane), II (Gare Pasteur) and III (Gare Vaugirard). Zones I and II serve the principal main-line platforms while Zone III comprises five platforms used by Intercity services to Argentan and Granville. There are twenty-eight platforms altogether. Some 50 million passengers a year use Paris-Montparnasse for main-line, suburban and regional services. Roughly half of these are long-distance travellers using TGV services. On average, 315 trains a day use the station.

High-speed TGV trains depart for many towns and cities in west and south-west France including Le Mans, Rennes, Brest, Nantes, Tours, Poitiers, La Rochelle, Bordeaux, Toulouse, Lourdes, Biarritz and Irun (Spain). An Intercity service links Montparnasse with Dreux, Argentan and Granville. Montparnasse is also served by regional and suburban trains for places west and south-west of Paris.

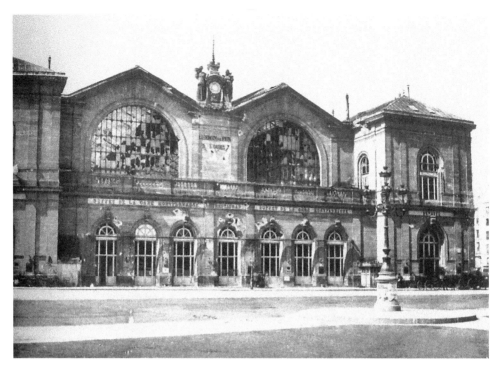

Montparnasse station, showing signs of the damage done during the Paris Commune of 1871.

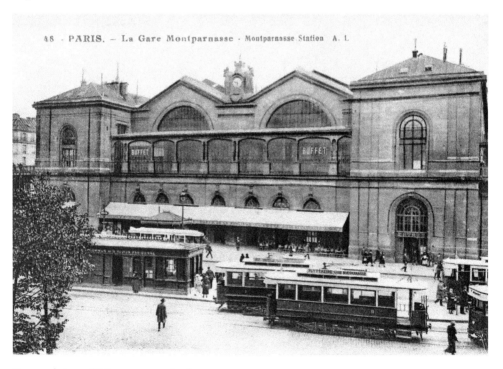

Postcard view of Montparnasse in the 1920s.

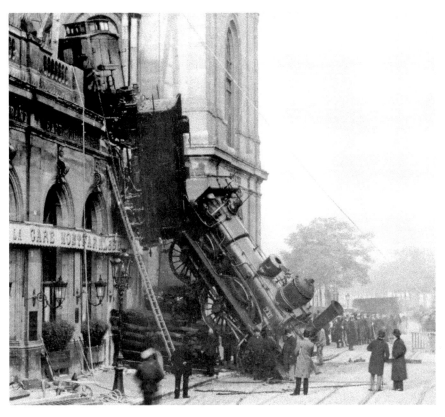

Aftermath of the spectacular train crash at Montparnasse in October 1895.

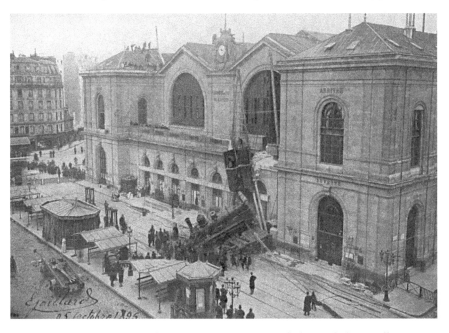

The Montparnasse train crash – recovery underway. (Vladimir Tkalčić's collection)

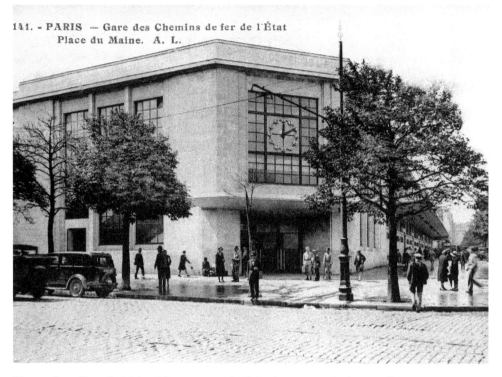

The art deco Gare du Maine-Montparnasse built in the 1930s. (Author's collection)

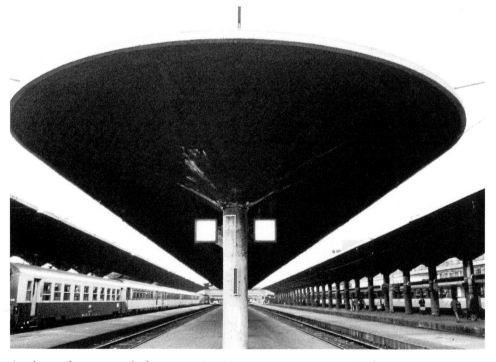

Art deco style concrete platform canopies at Montparnasse in 1988. (Author)

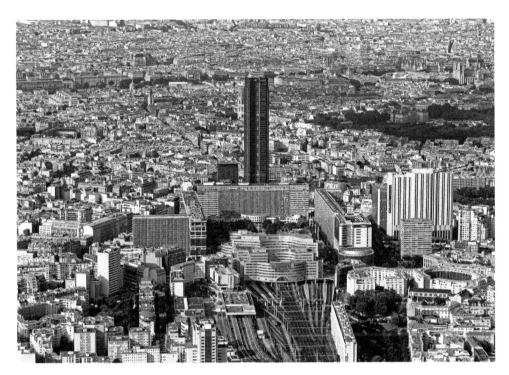

Aerial view of the station in 2013. The Montparnasse Tower skyscraper marks the location of the original station. (Michel Mensler)

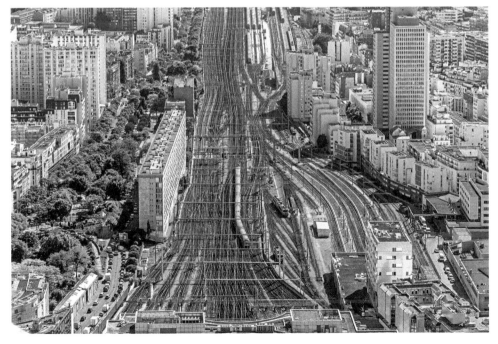

The tracks approaching the station seen from the viewing platform of Montparnasse Tower. (Rob Nopola, 2015)

The monumental scale of redevelopment at the new Montparnasse. (Author, 1985)

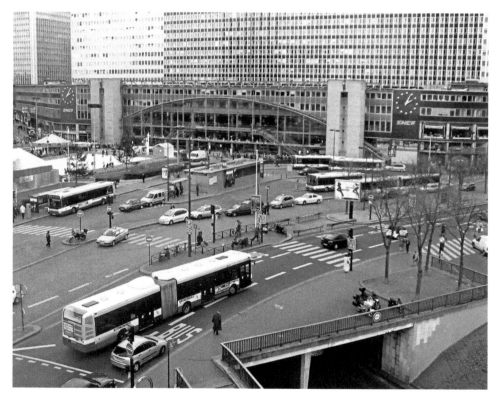

Another view showing the new frontage added in 1990. (Yann Kopf, 2003)

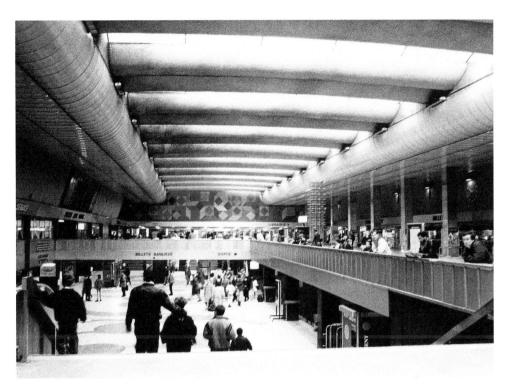

Multi-level concourse at Montparnasse in 1988. (Author)

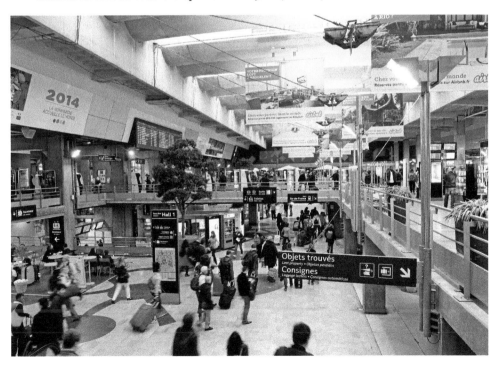

The multi-level concourse in 2014 – more cluttered than in 1988! (Chris Sampson)

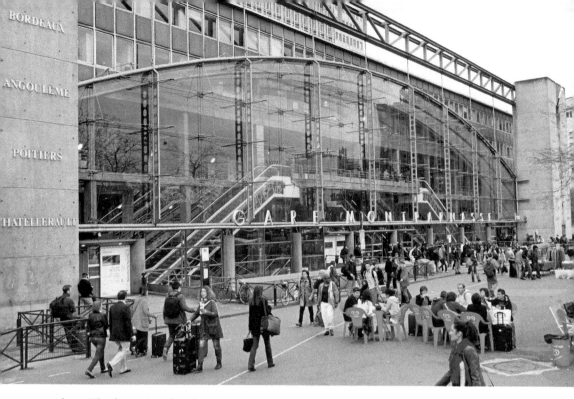

Above: The distinctive glass frontage. (Chris Sampson, 2014)

Below: Montparnasse at night. (Sébastien Couradin, 2014)

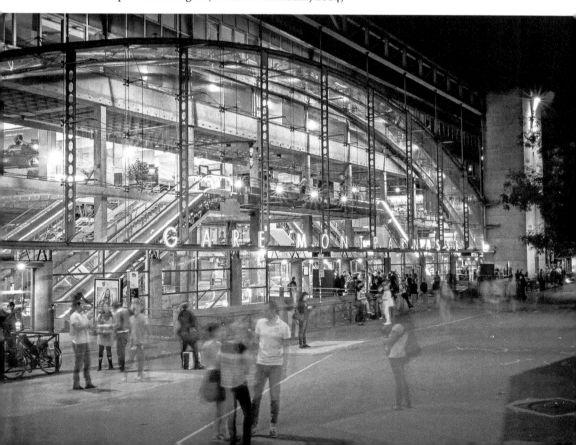

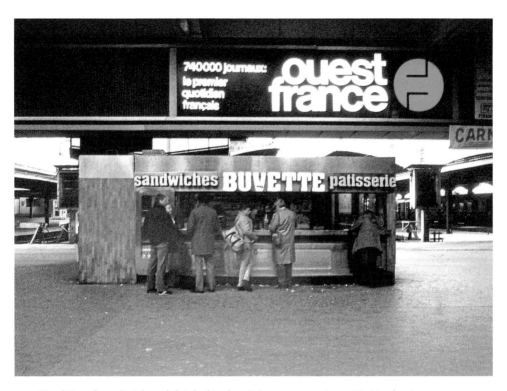

Traditional sandwich and drinks kiosk at Montparnasse in 1988. (Author)

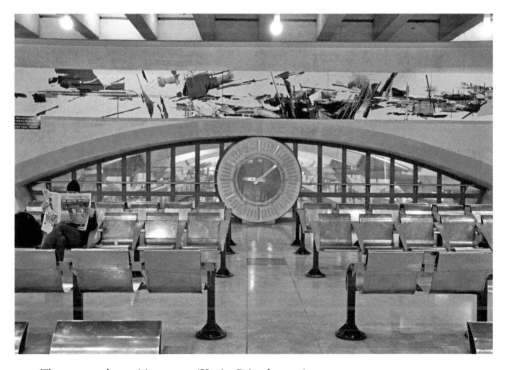

The spectacular waiting room. (Xavier Briand, 2010)

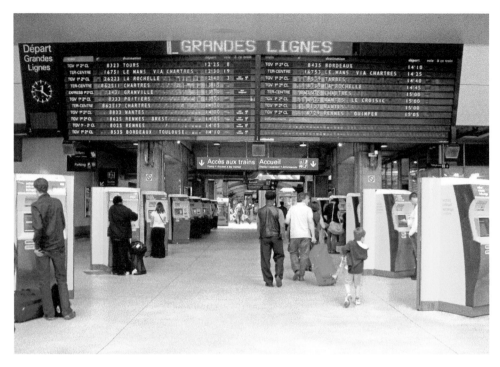

Departure indicator and ticket machines at Montparnasse. (Haniel Francesca, 2007)

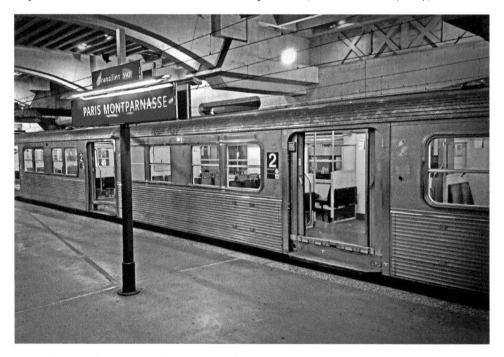

A stainless-steel electric suburban unit of Class Z5300, built in the 1960s/70s and nicknamed *petits gris* (little greys), on a Transilien service to Versailles at Montparnasse in 2014. (Yann Kopf)

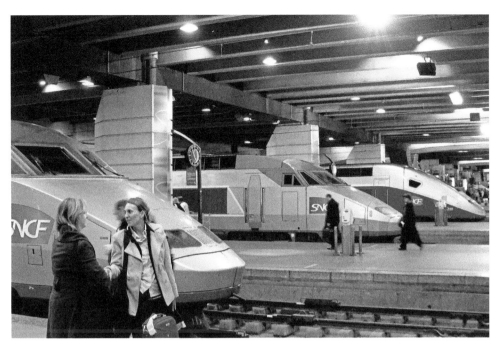

A line-up of TGV Atlantique services at Montparnasse. (Thangasivam Gandhi, 2008)

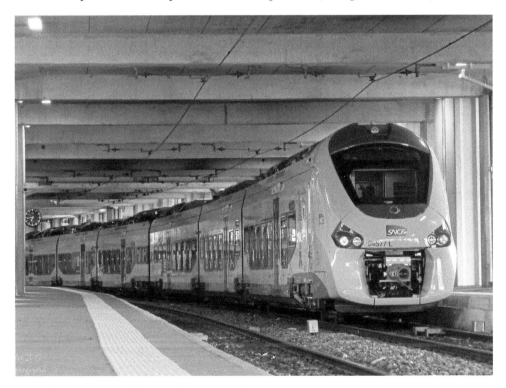

A bi-modal Regiolis train from Granville at Montparnasse III (Gare Vaugirard). (Oliver Aubry, 2015)

Gare d'Austerlitz

The Gare d'Austerlitz is situated on the left bank of the Seine in the south-eastern part of Paris. It is the terminus for the classic main lines to Bordeaux, Limoges and Toulouse. The station takes its name from the Czech town once known as Austerlitz (today Slavkov u Brna) where in 1805 the French Emperor Napoleon I defeated the combined forces of Russia and Austria. Designed by Félix-Emmanuel Callet, the station was built by the Paris-Orléans Railway Company and first opened in 1840 in order to serve a new line running south from Paris, which eventually reached Orléans in 1843.

Known as the Gare d'Orléans until 1900, the station was rebuilt between 1862 and 1867 to a design by Pierre-Louis Renaud, chief architect of the Paris-Orléans company. In common with many termini of the era, arrivals and departures took place on opposite sides of the station, requiring the construction of separate arrival and departure buildings. The vast train shed was designed by Ferdinand Mathieu and is one of the largest in France. During the siege of Paris in 1870, it was used as a workshop for manufacturing gas balloons to carry mail into and out of the city. The station was inundated during the great flood of 1910, which affected much of Paris. In 1926 it became the first Paris terminus to see the end of main-line steam on completion of the Paris–Vierzon electrification scheme.

Unlike other railway companies serving the capital, the Orléans Railway did not succeed in attracting many commuters. In an attempt to encourage the growth of suburban traffic, the French government launched an enquiry in 1896 to establish the feasibility of extending the line to a new central terminus on the Quai d'Orsay. The new Gare d'Orléans (later renamed Gare d'Orsay) opened in 1900 and the old Gare d'Orléans was renamed Austerlitz. The extension had only limited success and in 1939 all main-line traffic reverted to Austerlitz. In June 1940, amid scenes of chaos and confusion, it was from Austerlitz that the French government left Paris for the Loire as France fell to the invading German army.

Austerlitz station lost most of its long-distance services to south-west France with the introduction in 1990 of high-speed TGV Atlantique services, which use the Gare Montparnasse instead. Meanwhile many of its suburban services were incorporated

into the rapid-transit cross-Paris RER Line C, whose platforms are below the main-line station. Austerlitz used to have a number of sleeper trains to south and south-west France but these ended in 2007 when French Railways (SNCF) withdrew all internal sleepers. The Elipsos train hotels operated jointly by Spanish and French railways continued to depart from Austerlitz for Madrid and Barcelona but these too came to an end with the start of direct daytime TGV services from the Gare de Lyon to Barcelona in 2013.

A large refurbishment project at Austerlitz station began in 2011. Four new platforms have been added and the interior is being rebuilt. The new station will be able to handle TGV Sud-Est and Atlantique services partially displaced from the Gare de Lyon and Gare Montparnasse, both of which are at maximum capacity. The work is planned to be completed by 2020, by which time 23 million passengers a year are expected to be using Austerlitz. Passenger numbers will double by 2030 with the eventual opening of a projected new high-speed line to Lyon via Clermont-Ferrand. Sadly, rebuilding the station has involved demolishing the old station restaurant – Le Grenadier – a reference to the Battle of Austerlitz.

Daytime Intercity services currently operate from the Gare d'Austerlitz to cities including Orléans, Tours, Limoges and Toulouse, with regional services to Orléans, Châteaudun and Vendôme. Until 2016, Intercity Night services offering seats and couchette accommodation operated from Austerlitz to a wide range of destinations in south and south-west France. However, SNCF withdrew funding for the majority of these trains, claiming they were too expensive to operate. A few survive on grounds of social need, including those to Toulouse, Briançon, Rodez, Albi and La Tour de Carol.

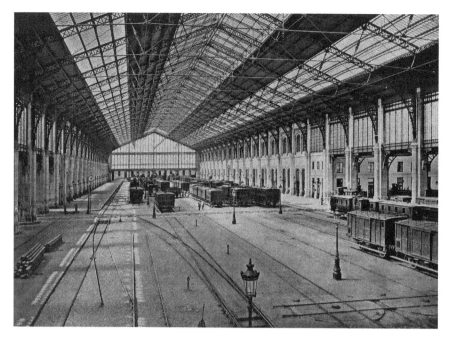

Train shed of the Gare d'Orléans, 1883 (renamed Austerlitz in 1900). The small turntables at the bottom right enabled locomotives to be turned or released on to an adjoining track and were quite common at several Paris termini in the nineteenth century.

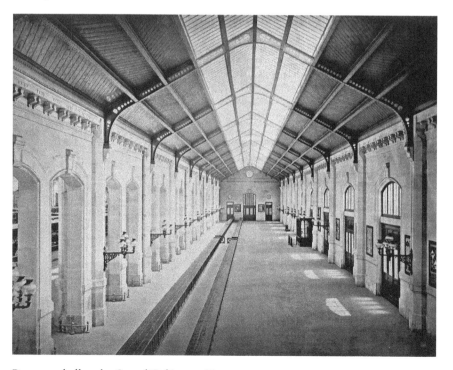

Passenger hall at the Gare d'Orléans, 1883.

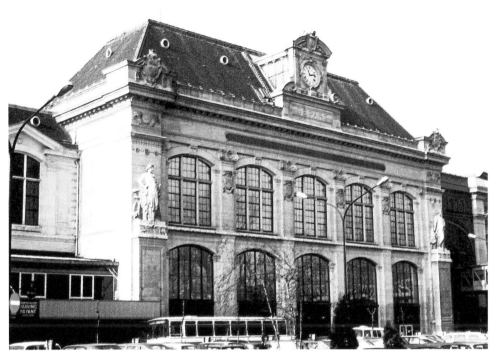

The 'Departures' building at Austerlitz. (Author, 1984)

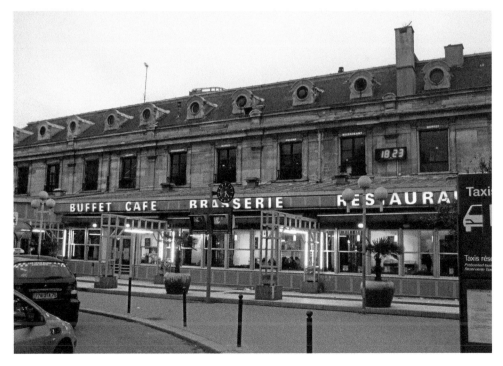

Restaurant, buffet, café and bar. Now demolished to permit redevelopment and enlargement of Austerlitz. (Mike Smee, 2010)

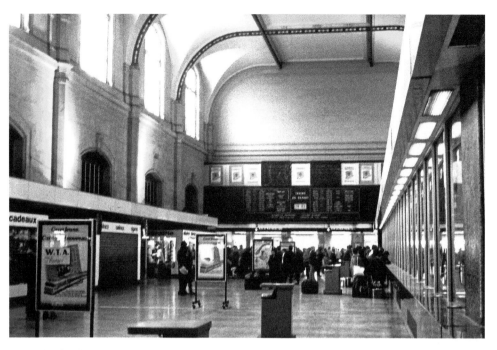

Austerlitz booking hall. (Author, 1984)

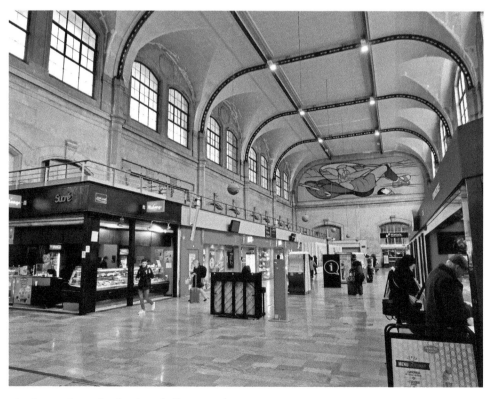

The former Austerlitz booking hall, now a shopping mall. (Patrice Koch, 2015)

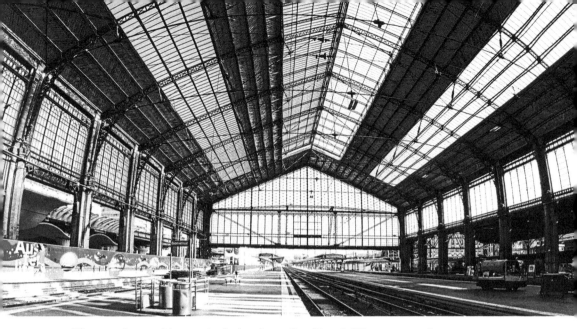

The vast glass-and-iron train shed at Austerlitz. (Benoit Wittamer, 2012)

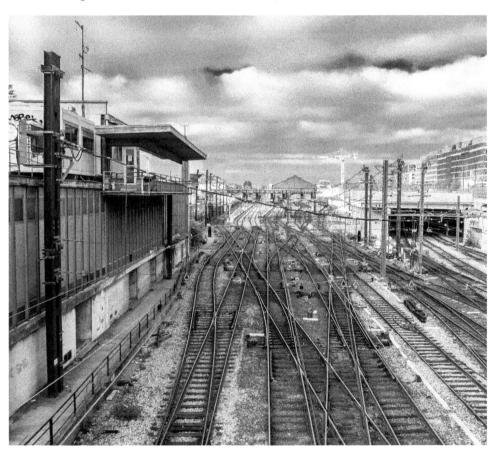

Approaching Austerlitz – the new platforms are in the concrete box on the right, the 1860s train shed can be seen in the distance. (Denis Trente-Huittessan, 2013)

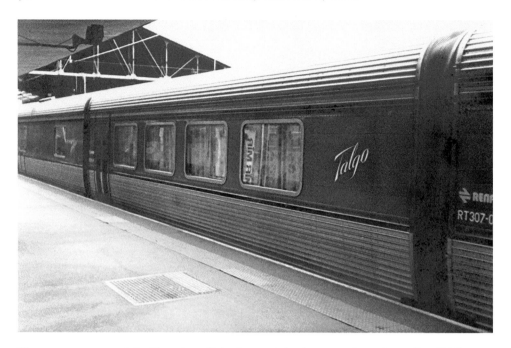

The restaurant car of the 'Barcelona Talgo' overnight sleeper train at Austerlitz. While passengers remained undisturbed inside, the train's wheelsets were adjusted at the Spanish border to allow for the change of track gauge. A similar train provided an overnight service from Austerlitz to Madrid. (Christian Torrego, 1986)

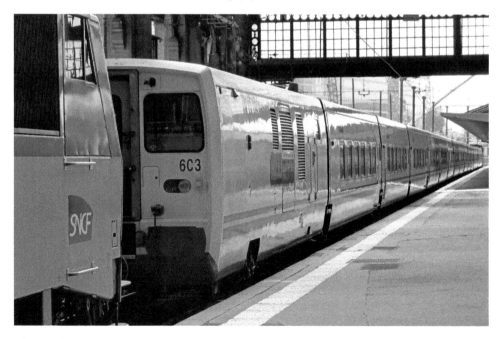

The Trenhotel – successor to the Barcelona and Madrid Talgos – at Austerlitz. These overnight trains were withdrawn in 2013 on the opening of direct TGV services between the Gare de Lyon and Barcelona. (Colin Churcher, 2011)

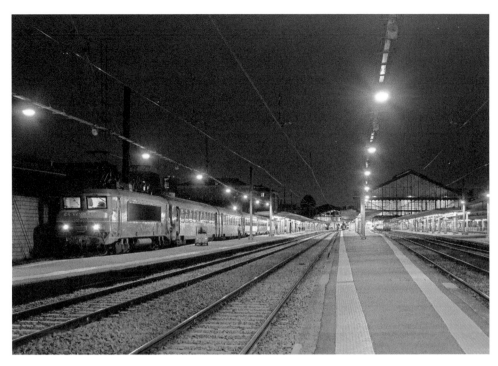

An atmospheric image of Austerlitz at night. (Mark Rijs, 2014)

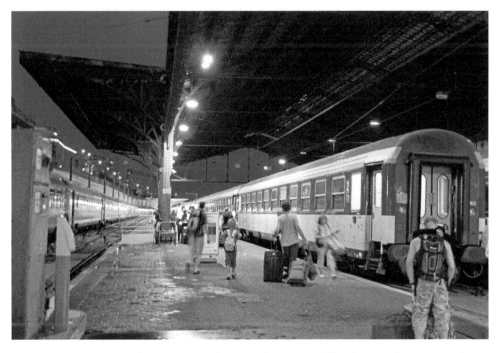

Passengers arriving for an Intercité de Nuit. These trains offered overnight accommodation in couchettes from Austerlitz to places in south and south-west France. Many of these services were withdrawn in 2016. (Anurag Chalmers, 2008)

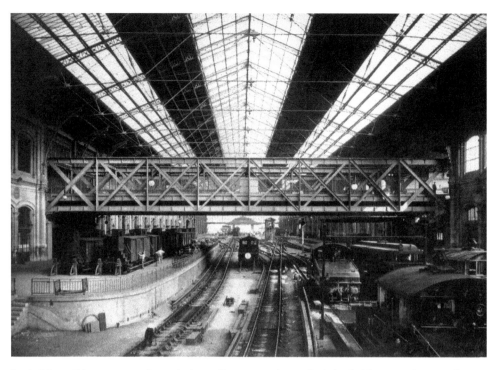

Paris Metro Line 5 passes through Austerlitz on an elevated girder bridge, seen here with the main-line station below in about 1900.

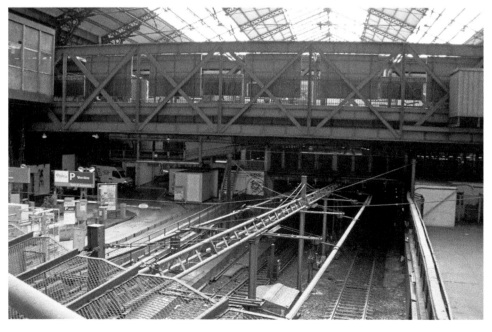

A modern view of the Metro bridge in the Austerlitz train shed with the tracks of RER Line C beneath. (Vincent BABILOTTE (Own work) [CC BY-SA 2.5], via Wikimedia Commons, 2006*)

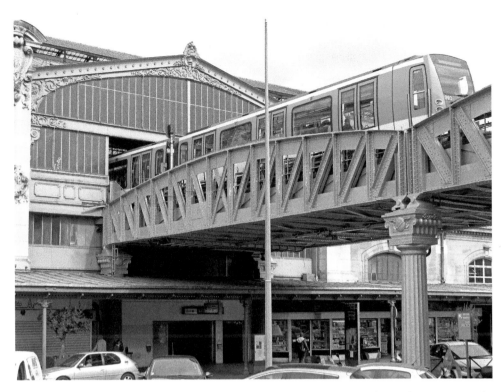

Metro Line 5 leaves Austerlitz through the side of the train shed... (Mbzt (Own work) [CC BY-SA 3.0], via Wikimedia Commons, 2014*)

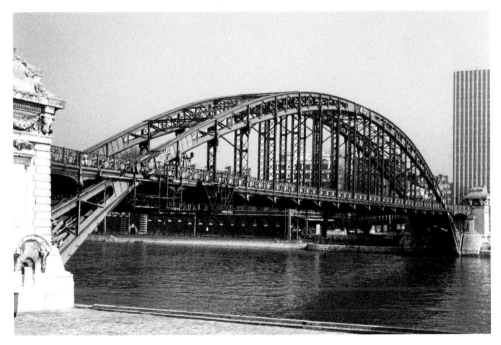

...and crosses the River Seine on this spectacular viaduct. (Author, 1984)

Building works underway to enlarge and modernise Austerlitz. This was the site of the former restaurant, now demolished. (Patrice Koch, 2015)

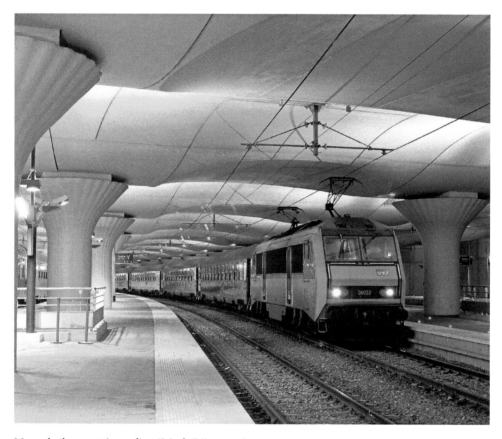

New platforms at Austerlitz. (Mark Rijs, 2014)

Gare du Nord

The Gare du Nord (North Station), located in a northern district of Paris, is the terminus for trains to northern France and destinations in Belgium, parts of Germany, the Netherlands, and the United Kingdom. Built for the Compagnie des Chemins de Fer du Nord (Northern Railway Company), the first station was inaugurated in 1846, the same year as the opening of the company's line to Amiens and Lille. It was originally known as the embarcadère du Nord (North embarkation platform). With only four platforms – two each for main-line and suburban services – the station quickly proved too small and was partially dismantled in 1860 to provide space for the current station. The original façade was removed and transported to Lille where it now forms the frontage of Lille-Flandres station.

Determined that the new station should be in suitably grand style, and in a bid to outshine the nearby Gare de l'Est, the Nord railway company appointed the leading architect Jacques Ignace Hittorff to design the replacement station complex. Building work started in 1861 and was completed in 1865, although the new station opened for service in 1864 while still under construction. The monumental stone façade in neoclassical style – three times the size of its predecessor – was designed around a central pavilion in the form of a 100-foot-high triumphal arch. This centrepiece is flanked by two smaller arches and arcaded wings stretching out to pedimented pavilions at each end. The principal elements of the design are separated by pairs of colossal Ionic pilasters. Hemmed in by adjoining buildings, the station frontage cannot easily be seen as a whole but its large scale and powerful design dominate its surroundings.

Sculptures in female form by some of the leading artists of the day depict twenty-three of the principal cities served from the Gare du Nord, including London, Berlin and Amsterdam. Eight majestic statues crown the station façade, with the ninth figure of Paris at the apex. Fourteen more modest statues representing other cities appear lower down. The train shed, engineered by François Léonce Reynaud who had designed the first Gare du Nord, has a pitched roof supported on slender cast iron columns made in Scotland – Great Britain being the only country at the time with a foundry large

enough to manufacture them – creating a magnificent impression of spaciousness under the 74-metre-wide shed.

The new Gare du Nord had the usual layout of a terminal station – two wings enclosing the separate arrivals and departures sides. Four platforms for suburban services in the centre were sandwiched between two for main-line arrivals and two for departures. The new station rapidly became too small to deal with the increasing traffic generated by the opening of new suburban lines. The number of platforms was first increased from eight to thirteen. To coincide with the Paris International Exposition of 1889, the station's interior was completely rebuilt, with an extension to accommodate suburban lines, increasing the number of platforms again to eighteen. In 1900 – another Exposition year – an annexe was constructed, further raising the number of platforms to twenty-eight.

The start of the First World War in August 1914 was heralded by a rapid German advance through Belgium and northern France. Hundreds of thousands of people descended on Paris by train to flee the German onslaught. It is estimated that 1,500,000 crossed from the Gare du Nord heading for the south and west of France before the Battle of the Marne halted the German advance in early September.

The outbreak of the Second World War in 1939 led to a drastic reduction in long-distance and international passengers. During the German occupation of Paris between 1940 and 1944, the Gare du Nord and the neighbouring Gare de l'Est were heavily used by the occupying power for war purposes, especially to transport the military as well as hundreds of thousands of French men and women who were deported to Germany as forced labour. Towards the end of the war, bombing raids by the Allied powers virtually destroyed the railway infrastructure on the approaches to the station, stopping all services for a time and causing massive disruption afterwards. The retreating German army added to the damage.

The Nord railway company was not unique in giving priority to its lucrative long-distance and international routes over the development of its suburban network, but the rapid growth of the suburbs in the early twentieth century forced it to invest in push-pull trains to increase operational flexibility and in more powerful locomotives to achieve better acceleration. Limited platform capacity at the Gare du Nord was tackled in the 1930s by closing some inner suburban routes made virtually redundant by the spread of the Metro, and by undertaking a vast programme to lengthen platforms. Even so, by 1938 suburban departures from Paris-Nord were still less than half those from Saint-Lazare. The problem was eventually solved by a post-war programme of overhead electrification, which came on stream at the Gare du Nord in 1958, allowing the introduction of more frequent, faster and cleaner trains, some with double-deck rolling stock. Despite this the Gare du Nord was the last terminus in Paris to have scheduled steam services, which continued on some routes until 1970.

The Gare du Nord was served by some of the great trains of the 'golden age' of European railways such as La Flèche d'Or (Golden Arrow) with Pullman cars to Boulogne and Calais for London, Nord-Express with sleeping cars for Copenhagen,

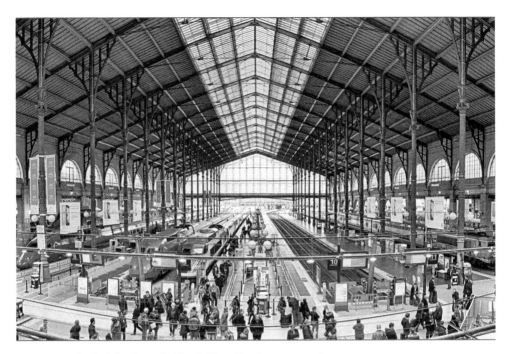

Train shed of the Gare du Nord. (Bert Kaufmann, 2016)

Berlin and Warsaw, and L'Étoile du Nord with Pullman cars to Brussels and Amsterdam. In 1957 the station became a key hub for the new network of prestige Trans-Europ-Expresses with trains to West Germany, Belgium and the Netherlands. The growth of air transport gradually undermined the finances of trains designed for the international business traveller and the 1980s began to see their replacement by EuroCity expresses open to both first and second-class ticket holders. From the 1990s these in turn were replaced by high-speed TGV services, which have not only drastically reduced journey times but also greatly increased service frequency.

In the late 1970s work began on the construction of new underground platforms for suburban services, eventually linking in with the rapid-transit cross-Paris RER lines B and D, which opened in the early 1980s. This released platform space in the main station, which was eventually taken up by TGV services. These began operating on the new Nord high-speed line in 1993. Eurostar services to London via the Channel Tunnel started in 1994, Thalys services to Brussels and Amsterdam following in 1996. Platforms had to be lengthened to accommodate these trains.

Based on the number of travellers – around 262 million per year including those using the RER lines serving the station – the Gare du Nord claims to be the busiest railway station in Europe with over 700,000 passengers arriving or departing daily on 1,500 trains. Roughly three-quarters are commuters travelling from the northern suburbs of Paris and outlying towns. In 2001 the station gained a striking new interchange hall linking together the pedestrian flows between main-line, suburban and underground lines. This takes the form of a double span of steel and glass, creating

a transparent, luminous space containing not only a passenger concourse but also a shopping mall.

The Gare du Nord has at times battled against decay and delapidation, to the point of being threatened with demolition in the 1950s. Despite frequent modernisation and a renewed emphasis on security, the station has a long-standing reputation for being a gathering point for beggars, drug dealers, pickpockets and criminal gangs. In 2013 the British ambassador stated that it was a shame that the first experience of Paris for many British visitors was to have their pockets picked or their luggage stolen at the Gare du Nord, while in 2015 the head of the John Lewis chain of department stores caused controversy when he described the station as 'the squalor pit of Europe'. This is nothing new. As early as 1854, local residents petitioned the city authorities about the appalling state of the station's environs, facilities and road access and demanded the area's reconstruction. To make the Gare du Nord fit for the twenty-first century, it is undergoing another major refurbishment.

The following main-line train services currently use the Gare du Nord:

High-speed Eurostar services to London;
High-speed international Thalys services to Brussels, Amsterdam, Cologne, Essen and Dortmund;
High-speed domestic TGV services to Lille, Calais, Boulogne, Dunkerque, Arras, Douai and Valenciennes;
Intercity services to Amiens, Abbeville, St-Quentin and Cambrai;
Regional and suburban services to places north of Paris including Soissons, Laon, Creil, Compiegne, St-Quentin, Beauvais and Amiens.

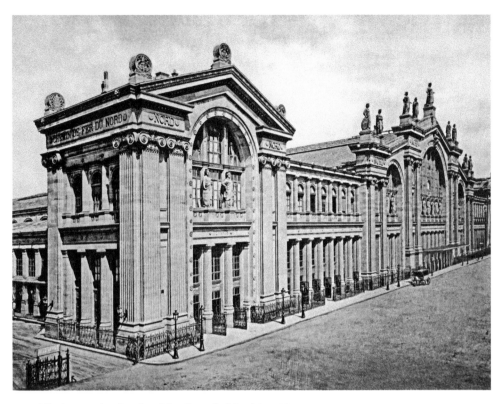

The impressive façade of the Gare du Nord in 1883.

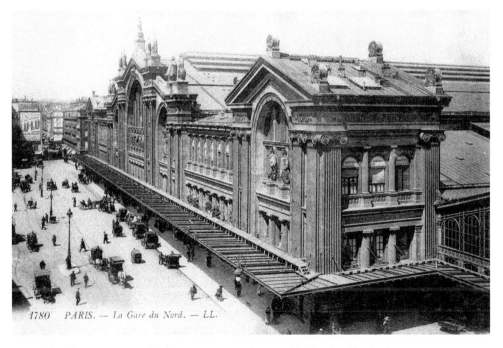

A bustling scene outside the station around 1900. (Author's collection)

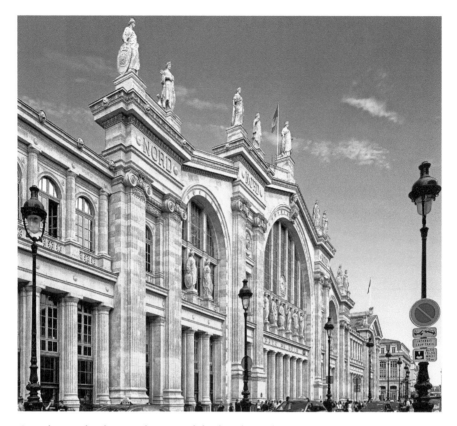

Gare du Nord – the grand sweep of the façade. (Velvet (Own work) [CC BY-SA 3.0], via Wikimedia Commons, 2013*)

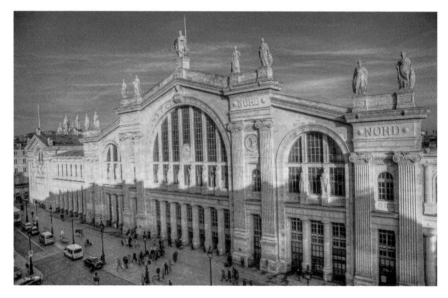

The façade catches the morning sun with the Basilica of Sacré Coeur visible above the roofline on the left. (Stewart Leiwakabessy, 2011)

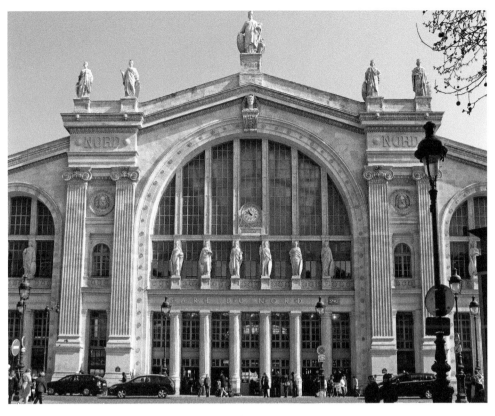

The central arch of the façade. (Sébastien Nguyen van Tam, 2013)

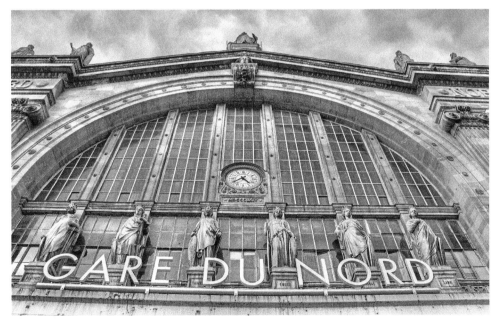

The 100-foot-high central arch seen from below. (Nic Oatridge, 2007)

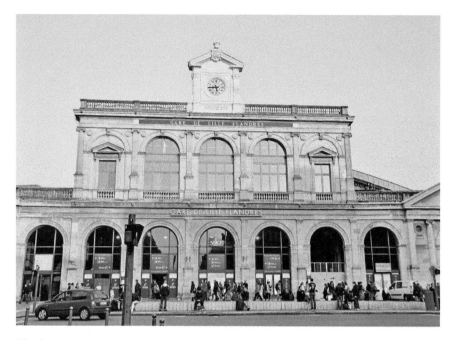

The first Gare du Nord was partly dismantled in 1860 to make way for the present station. The façade was transported to Lille where it now forms the frontage of Lille Flandres station. (Patrice Koch, 2014)

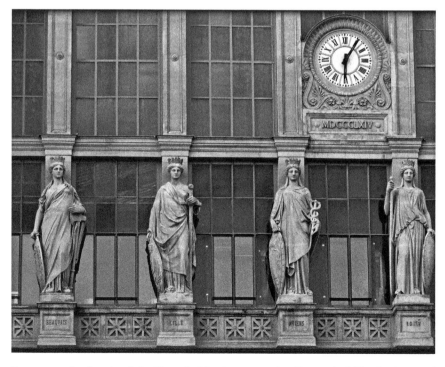

Statues on the façade of the Gare du Nord representing Beauvais, Lille, Amiens and Rouen; the date carved under the clock – 1864. (Miroslav Pejic, 2014)

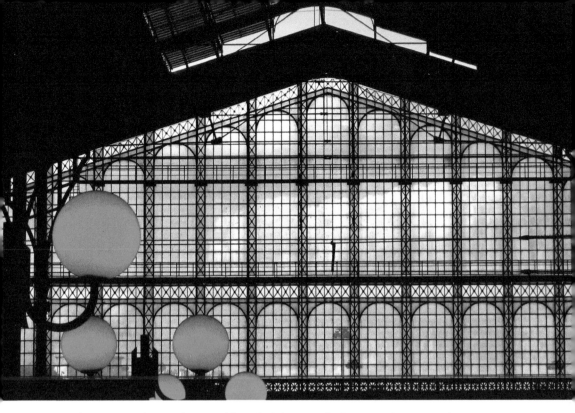

The intricate glass-and-iron gable end of the train shed. (Bernard Fourmond, 2007)

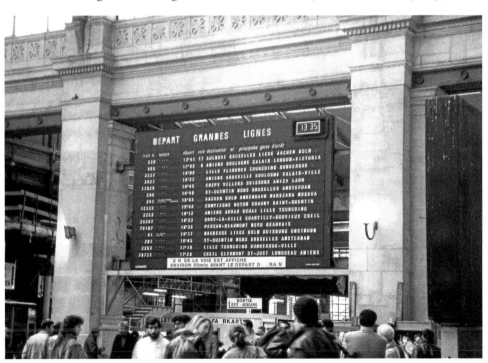

A familiar sight to generations of travellers – the Grandes Lignes departure indicator. (Colin Churcher, 2008)

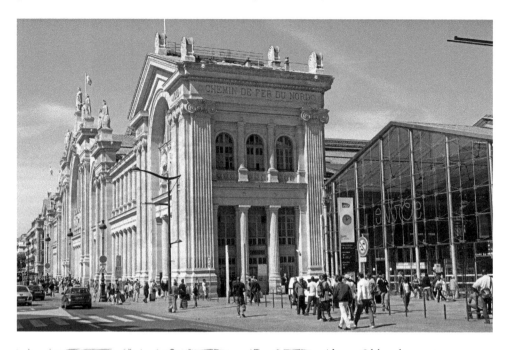

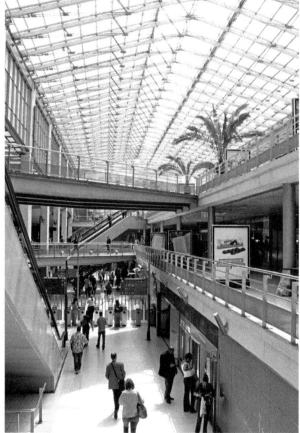

Above: Old and new at Nord – the 2001 glass extension sits alongside the nineteenth-century façade. (Nik Morris, 2013)

Left: The extension includes shops and allows easier interchange with Metro and RER services. (Claude Shoshany (Own work) [CC-BY-SA-3.0], via Wikimedia Commons, 2007*)

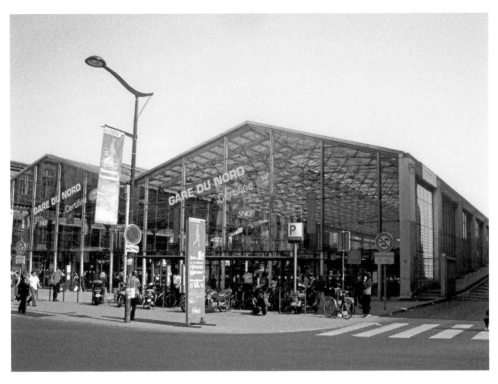

The glass extension by day... (Haniel Francesca, 2007)

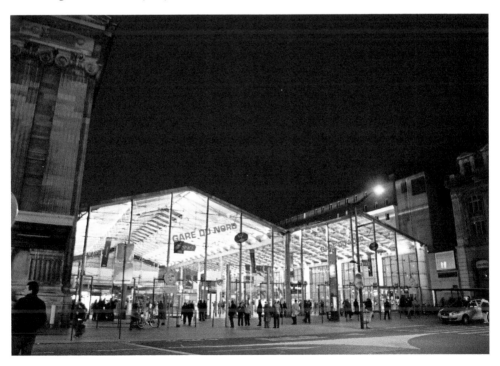

...and by night. (Pascal Poggi, 2008)

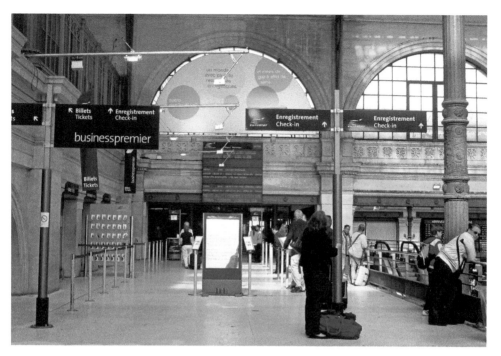

Eurostar check-in at Paris-Nord. In 1998, a large balcony was constructed to provide additional space and dedicated facilities for Eurostar passengers, including refreshment facilities, a ticket office, control of tickets and passports, and waiting areas. (Haniel Francesca, 2007)

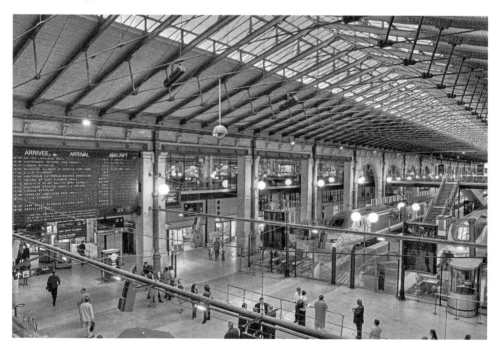

Looking down from the balcony towards the Eurostar platforms. (Nic Oatridge, 2007)

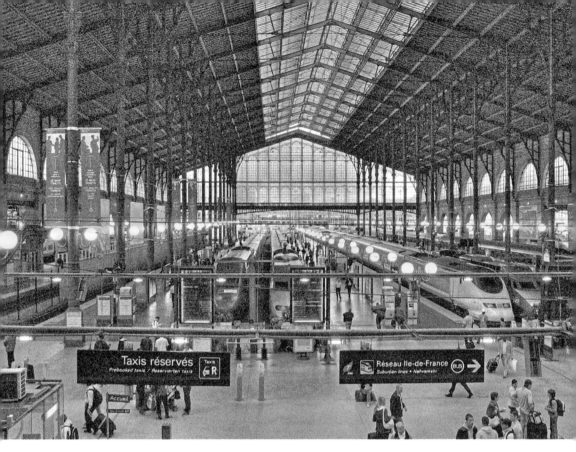

The balcony provides a perfect viewing platform, looking out across the train shed and concourse. (Nic Oatridge, 2007)

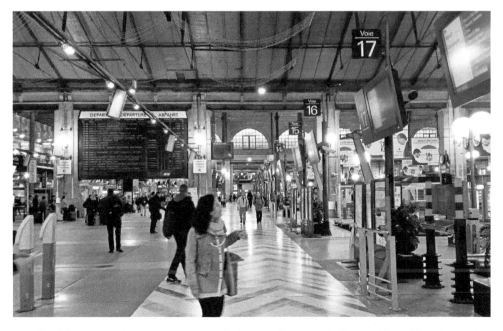

Looking across the concourse towards the new departure indicator. (Pascal Poggi, 2014)

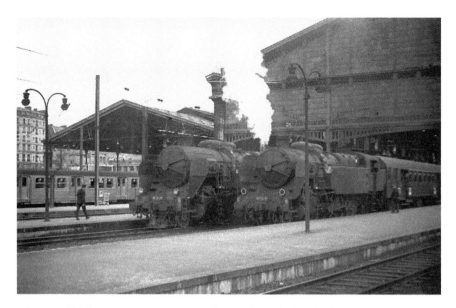

Class 141TC locomotives prepare to depart from Paris-Nord with two commuter trains in 1969. The intensive suburban push-pull service was operated by these big 2-8-2 tank locos. (Pete Hackney)

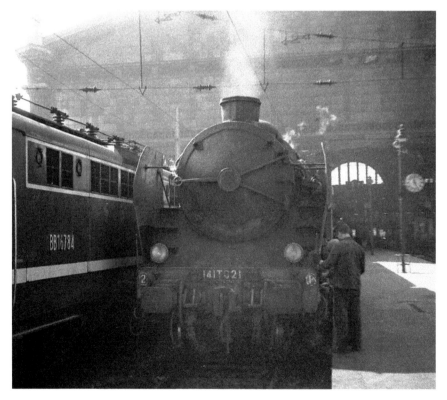

Another commuter service leaves the Gare du Nord hauled by a Class 141TC. (Pete Hackney, 1969)

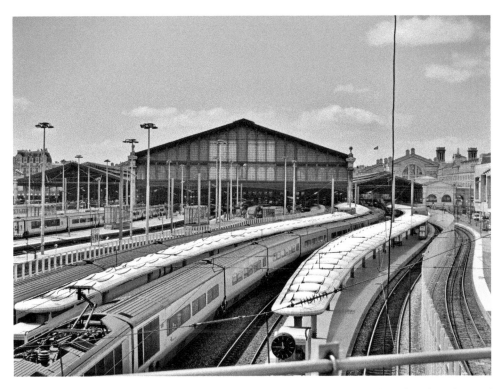

Steam is long gone and Eurostars for London now leave from lengthened and modernised platforms. (Patrice Koch, 2013)

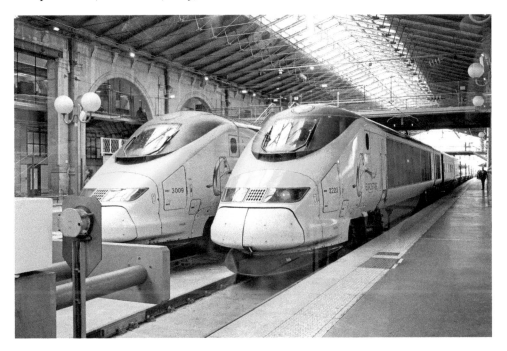

A pair of Eurostars awaiting their next duty. (Chris Sampson, 2014)

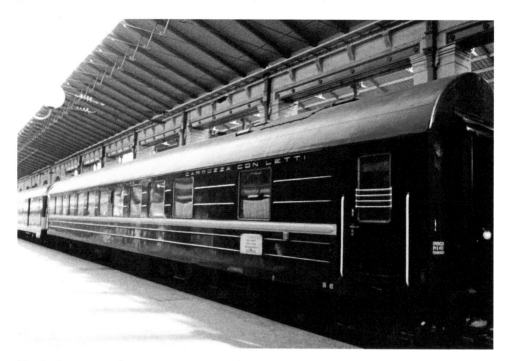

The Paris–Moscow sleeping car prepares to depart from the Gare du Nord on its two-night journey to the Soviet Union as part of the Ost-West Express. Its present-day successor leaves from the Gare de l'Est. (Author, 1988)

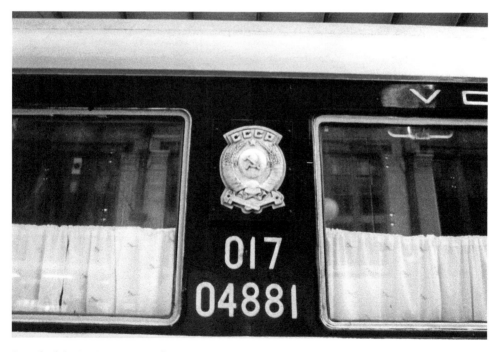

Detail of the Paris–Moscow sleeping car. USSR car No. 017 04881 proudly displays the insignia of the Soviet Union. (Author, 1988)

Passengers waiting to board the Paris–Copenhagen sleeper of the Nord-Express, one of the great trains for which Paris-Nord was famous. (Author, 1996)

The advent of high-speed services has revolutionised rail travel, leading to the demise of classic overnight trains such as the Nord-Express. Thalys and TGV-Nord sets sit side-by-side at the Gare du Nord. (Haniel Francesca, 2007)

Gare de Lyon

About 90 million passengers use the Gare de Lyon every year, making it one of the busiest in Europe. It is the northern terminus of the line linking France's three largest cities – Paris, Lyon and Marseille. The station is located on the right bank of the River Seine in the eastern part of Paris.

The first station on the site was a makeshift timber affair that began operating in 1847 and was formally opened to the public in 1849 by the Paris-Lyon railway company, the forerunner of the grandly named Compagnie des Chemins de Fer de Paris à Lyon et à la Méditerranée (PLM for short). The first Gare de Lyon was quickly overwhelmed by the growth in traffic and had to be altered several times, culminating in the construction of a second station in 1855. This new station was built on foundations raised up by several metres to prevent flooding from the nearby river. Like its predecessor, the second Gare de Lyon was designed by François-Alexis Cendrier. Consisting of just five tracks in a 220-metre-long train shed, it had to be rebuilt after being partly burnt down during the Paris Commune uprising of 1871.

A new, much larger thirteen-track Gare de Lyon was required to accommodate the vast crowds visiting the Paris Exposition of 1900. Designed by the architect Marius Toudoire, the station took three years to build. Its impressive façade is a classic example of the architecture of its time: seven monumental arched portals extend along the ground floor frontage, the first floor windows above appearing diminutive by comparison. An overpowering roofline is punctuated by two rows of dormers. The façade is given shape by a series of pavilions and bays but the symmetry is interrupted by the building's most notable feature – a gigantic clock tower topped with a zinc dome. In all, the station is one of the most spacious of the nineteenth-century Paris termini, presenting an architectural unity with fine detailing ranging from clocks to statuary.

The extent of the facilities to be found at major termini in the inter-war period can be judged by those provided at the Gare de Lyon in 1931. These included a booking hall with seventy ticket and baggage windows, separate departure and arrival left-luggage offices, an information and telegraph office, a bureau de change, a sleeping-car company office, twelve automatic luggage weighing machines, two waiting rooms,

lavatories and baths, hairdressing and shoe cleaning rooms, a buffet and restaurant, ticket collectors' and other offices, a luggage arrival hall, customs hall, lost property office, station master's office, police office and medical rooms.

Replacement of steam by electric traction on the main lines out of the Gare de Lyon was completed in 1952. In 1981 the start of TGV Sud-Est services on France's first high-speed line required the construction of five new tracks in the station. The original Sud-Est line was subsequently extended by the opening of the Rhone-Alpes, Mediterranean and Rhine-Rhone high-speed lines.

In 1988, fifty-six people died at the station when an incoming commuter train crashed into a stationary outbound train. The subsequent investigation found that after a passenger had activated the emergency brake earlier in the journey, the driver and guard of the incoming train had reset the brakes in a way that led to a catastrophic loss of braking power.

Main-line trains depart from thirty-two platforms, with a further four platforms for RER Paris regional rapid-transit services beneath the main lines. Direct high-speed TGV services from the Gare de Lyon serve many towns and cities in a great swathe of south-eastern France including Lyon, Avignon, Aix-en-Provence, Marseille, Cannes, Toulon, Nice, Montpellier, Narbonne, Perpignan, Grenoble, Chambéry, Aix-les-Bains, Belfort, Mulhouse, Dijon, Besançon, Saint-Etienne, Valence and Bourg-Saint-Maurice. Direct TGV services also operate to Girona and Barcelona (Spain), Geneva, Basel, Zurich, Bern, Interlaken, Lausanne and Neuchatel (Switzerland), Turin (Italy), and Freiburg im Breisgau (Germany). The Gare de Lyon is also the main base for regional services to Burgundy.

A night train to Italian destinations connects the Gare de Lyon with Milan, Verona, Padua and Venice. This is the sole survivor of many sleeping-car services that as late as the 1990s left the station each night for destinations including Rome, Naples, Florence, Genoa, Marseille, Nice and the French Alpine resorts. High-speed trains and low-cost airlines have brought a relatively rapid end to classic night trains in much of Europe.

Extensive work is underway to enlarge the Gare de Lyon's capacity to cope with a projected 30 per cent increase in passenger numbers in the coming decade.

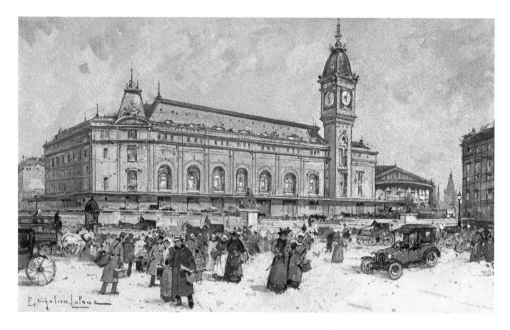

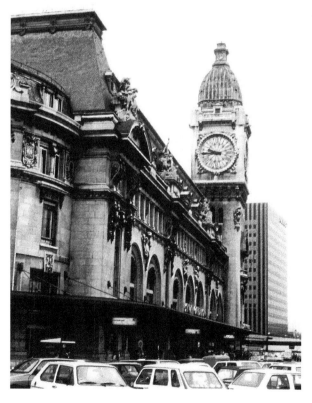

Above: The Gare de Lyon
as depicted by artist Eugene
Galien-Laloue in 1910.

Left: The façade and clock
tower. (Author, 1984)

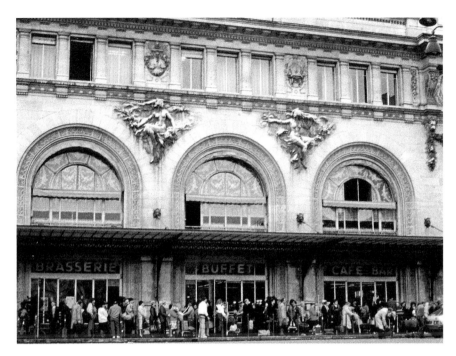

Voluptuous carved figures representing shipping and steam keep watch over a colourful taxi queue. (Author, 1984)

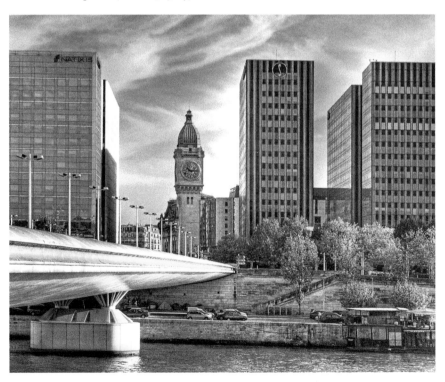

The clock tower in its twenty-first-century setting. (Jean Rachez, 2009)

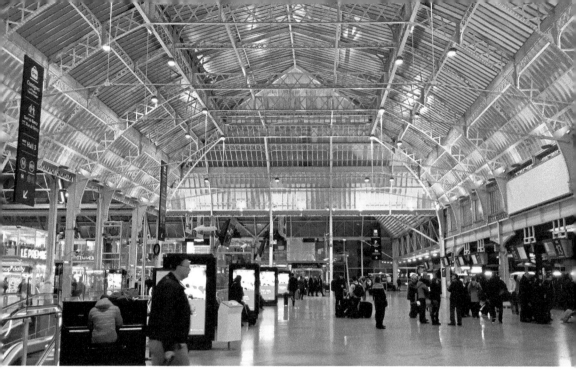

Gare de Lyon – the concourse. (Pascal Poggi, 2014)

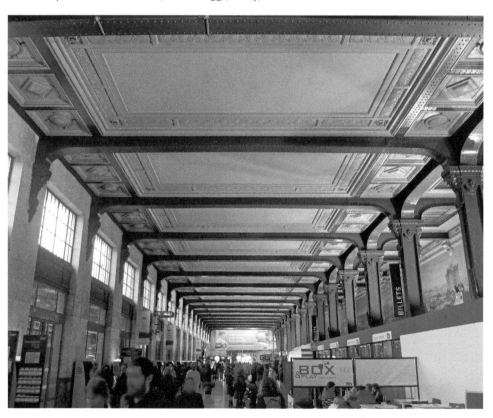

The booking hall. (Mbzt (Own work) [CC BY-SA 3.0], via Wikimedia Commons, 2011*)

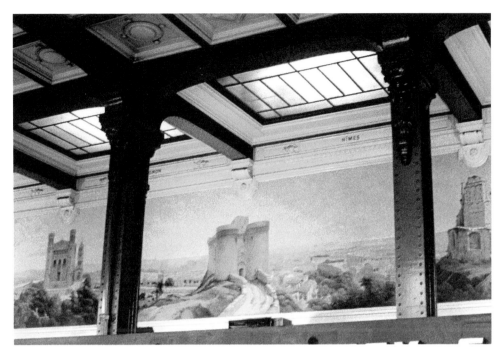

Running the whole length of the booking hall above the ticket office windows is a vast frieze painted by Jean-Baptiste Olive. In one continuous mural, part of which is shown here, it depicts most of the notable towns and cities served by trains from the Gare de Lyon. (Author, 1984)

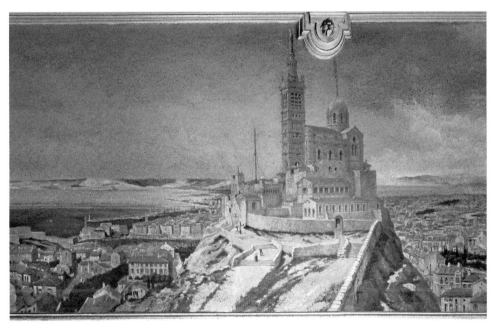

A detail of the mural representing Marseille. (Pascal3012 (Own work) [CC BY-SA 3.0], via Wikimedia Commons, 2011*)

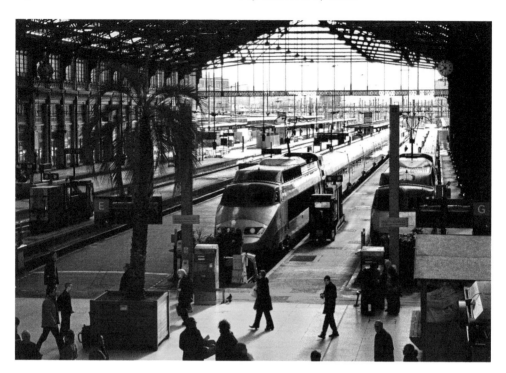

Paris-Lyon – TGVs and part of the train shed lit up by the morning sun. (Pascal Poggi, 2010)

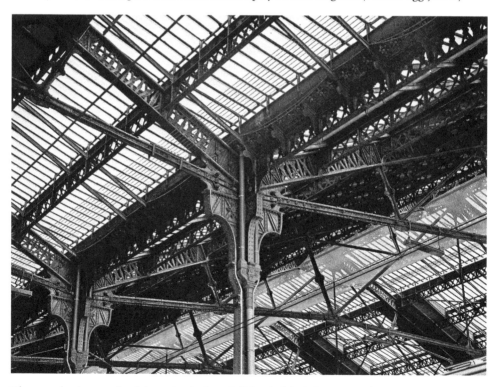

The complex ironwork of the train shed roof. (Mattéo Mechekour, 2014)

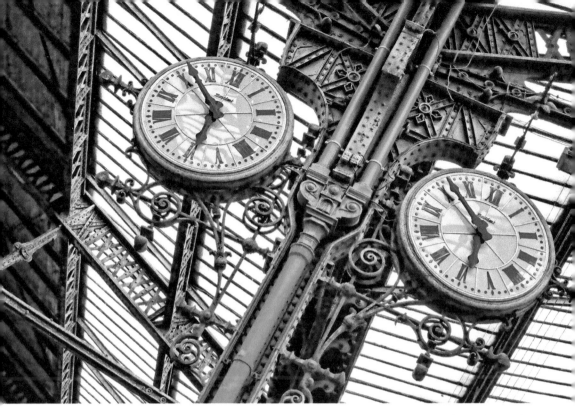

A colourful mix of clocks, ironwork and downpipes for draining water from the roof. (Marc Heurtaut, 2013)

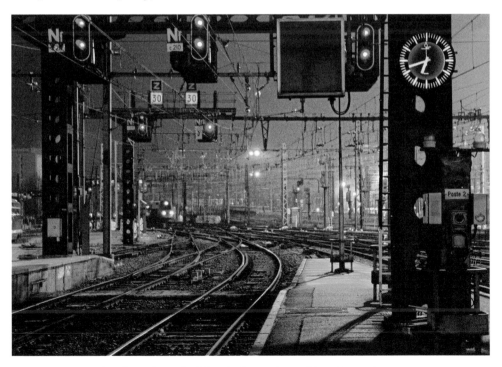

An evening shot from the end of the platforms. (Pascal Poggi, 2010)

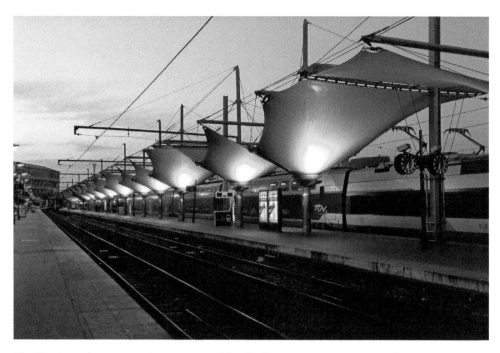

The illuminated canvas awning over one of the platforms at Paris-Lyon. (Pascal Poggi, 2014)

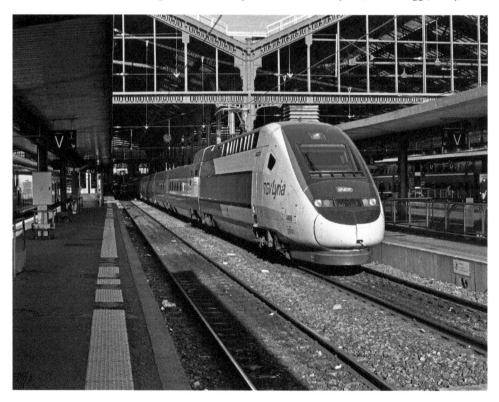

TGV Lyria train on a service from Zurich. (Leen Molema, 2015)

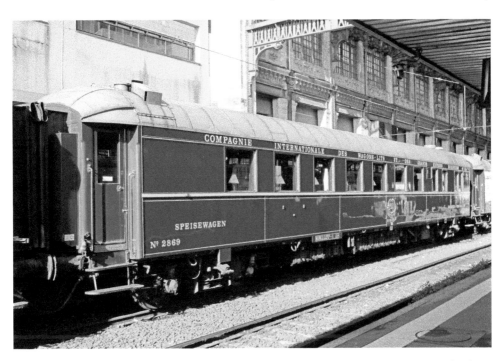

Restaurant car of the modern-day luxury Venice Simplon Orient Express looking resplendent in Wagon-Lits colours at the Gare de Lyon. Car No. 2869 was built in Smethwick, England, in 1929. (Didier Duforest, 2013)

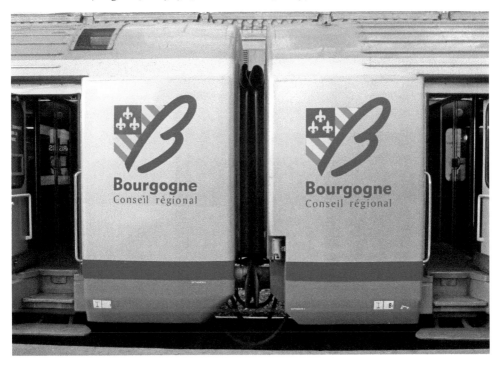

A regional unit operating under the brand of Burgundy Regional Council. (Nik Morris, 2013)

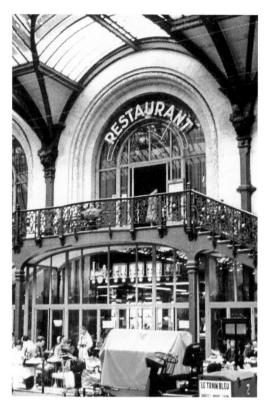

Left: On the first floor, reached by an ornate curving iron staircase rising from the concourse, can be found the entrance to the 'Train Bleu' restaurant. Opened in 1901, it is named after the Blue Train of luxury sleeping cars that once ran nightly from the Gare de Lyon to the French Riviera. (Author, 1984)

Below: The magnificently ornate interior of the 'Train Bleu' restaurant in Second Empire style. (Colin Churcher, 2014)

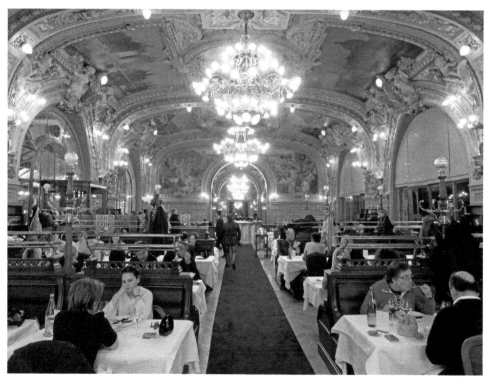

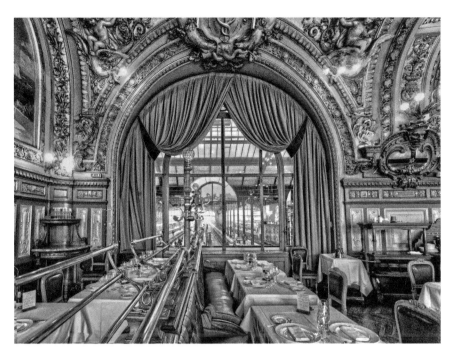

A study of the exceptional detailing in one corner of the 'Train Bleu' restaurant. (Stéphanie Benjamin, 2014)

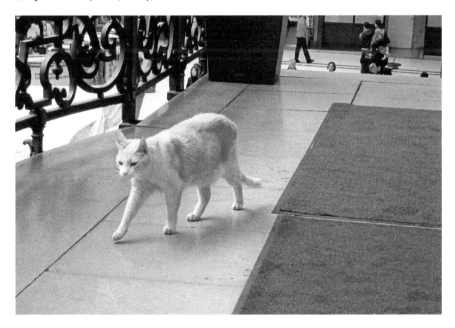

For years a ginger and white cat has been a feature of the 'Train Bleu'. The story goes that when the chef who owned it moved on, the cat decided to stay. As it was a good mouser, it became a member of staff and was put on the payroll. The 'Train Bleu' cat, seen here on the balcony outside the entrance, even learned how to negotiate the revolving doors when they were being used by customers. (Colin Churcher, 2012)

Gare de l'Est

The Gare de l'Est (East station) is located in the northern part of Paris near the Gare du Nord and is the western terminus of the principal main lines to Strasbourg and Mulhouse in eastern France. Anxious to keep the costs of building the railway under control, the Compagnie du Chemin de Fer de Paris à Strasbourg (the Paris-Strasbourg Railway Company) initially hoped to terminate its new line at one of the capital's other stations (Nord, Lyon or Austerlitz) but the state authorities insisted on a separate terminus to improve railway operating standards and assist the distribution of passengers around Paris.

Work on the new station began in 1847. It opened in 1849 and was formally inaugurated in 1850 by Louis-Napoleon Bonaparte, President of the Republic and future Emperor Napoleon III, although work was not completed until 1852. The station was designed by the architect François-Alexandre Duquesney. At first known simply as the embarcadère de Strasbourg, it comprised just a single platform for arrivals and one for departures in a large single-span train shed engineered by Pierre Cabanal de Sermet. In 1854 the number of platforms was doubled to four to accommodate traffic on the new line to Mulhouse, then under construction, and the station was renamed the Gare de l'Est, the company itself having been transformed into the Compagnie des Chemins de Fer de l'Est (the Eastern Railway Company).

Architecturally the station's most striking feature is the way in which the round-arched form of the original glass and iron train shed is expressed in the shape of an enormous semi-circular window in the centrepiece of the original façade. The station is set back in a large enclosed courtyard with a ground floor colonnade running across its width. The design was intended to be a celebration of the railway as a new transformative means of transport, although some of the ornamental features originally planned were criticised as being too bold and had to be eliminated before the design received official approval. The Gare de l'Est was – and still is – widely regarded as one of the most beautiful stations in the world and has influenced the design of many others.

The station was further enlarged in the 1880s and again in 1900, by which time it had been equipped with sixteen platforms. To achieve this, all tracks were

removed from the original train shed, which was converted into an enormous *salle des pas perdus* (passenger hall), and, for the first time, the new platforms were used interchangeably for both arrivals and departures. Between 1926 and 1931 the station was again doubled in size to thirty platforms and assumed the appearance it has today, with the new extension built symmetrically so as to be a mirror image of the original.

As the terminus of a strategic railway network extending towards the eastern part of France, the Gare de l'Est saw large mobilisations of French troops at the beginning of the 1870 Franco-Prussian War as well as both world wars. The 1870 arrangements were chaotic. On the first day, trains were so badly organised that soldiers waiting hours to depart got hopelessly drunk while ammunition was looted by souvenir hunters. Nevertheless over the next nineteen days 300,000 men, 65,000 horses and 5,000 wagonloads of supplies left the capital in a thousand trains.

The station has been home to some famous trains over the years. 1883 saw the first departure of the Orient Express for Constantinople in Turkey, modern-day Istanbul. Although interrupted in times of war, the through sleeping-car service continued until 1977, by which time it left Paris twice a week, arriving in Istanbul three days later. The main lines serving the Gare de l'Est were electrified in 1962.

The Gare de l'Est was extensively renovated to coincide with the opening of the new high-speed TGV-Est line in 2007, with TGVs operating to north-eastern France, Luxembourg, southern Germany and Switzerland, including some services provided by German Inter City Express (ICE) trains. The station is used by 30 million passengers each year, a figure which has grown by 22 per cent since the introduction of TGV services.

The main-line platforms are divided into two zones. Platforms in the original station are principally used by trains for Alsace and by international services, while platforms in the newer part are used by trains to Champagne-Ardenne and Lorraine. Suburban services operate from platforms located between these two zones.

The following train services are based at Paris-Est:

A weekly EuroNight service to Hannover, Berlin, Warsaw, Brest, Minsk and Moscow;
Domestic high-speed TGV services to a range of cities in eastern France including Reims, Charleville-Mézières, Sedan, Bar-le-Duc, Nancy, Lunéville, Strasbourg and Metz;
International high-speed TGV/ICE services to Luxembourg and to the German cities of Saarbrücken, Kaiserslautern, Mannheim, Frankfurt, Karlsruhe, Stuttgart, Ulm, Augsburg and Munich;
Intercity and Regional services to locations in eastern France not served by TGVs.

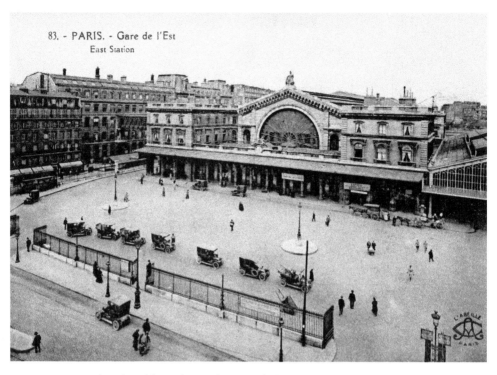

Set in a courtyard enclosed by railings, the Gare de l'Est has been described as the most beautiful railway station in the world. In this scene from around 1900, motor taxis await their next fare. The glass-and-iron shed to the right of the buildings was demolished when the station was doubled in size between 1926 and 1931. (Author's collection)

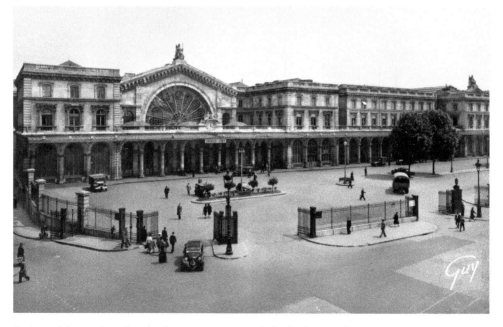

A view of the station after the frontage was extended. (Author's collection)

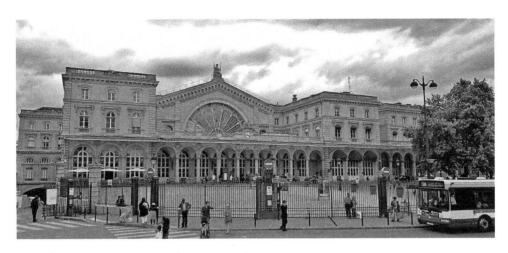

The station in 2011. (Doods Damaguing)

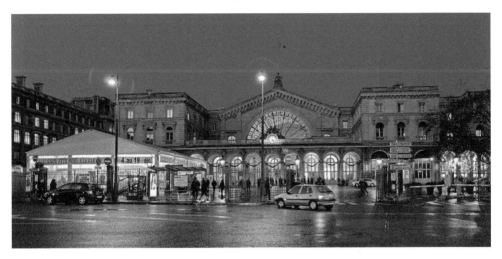

Station frontage at dusk. (Jorge Láscar, 2014)

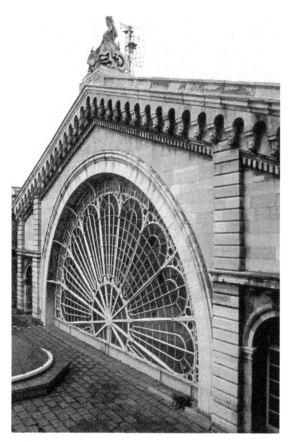

Left: The semi-circular wheel window in the gable end of the original train shed. On the crest is a statue by the sculptor Philippe Joseph Henri Lemaire representing the city of Strasbourg. The newer eastern side extension has a statue by Henri Varenne representing the spirit of Verdun – location of an epic battle of the First World War – in the form of an armed and helmeted female warrior with sword and shield. (Author, 1993)

Below: The original train shed, now a passenger hall, leads to the platforms located beyond the archway. (Nic Oatridge, 2007)

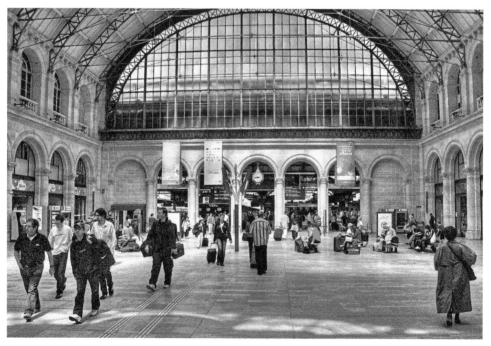

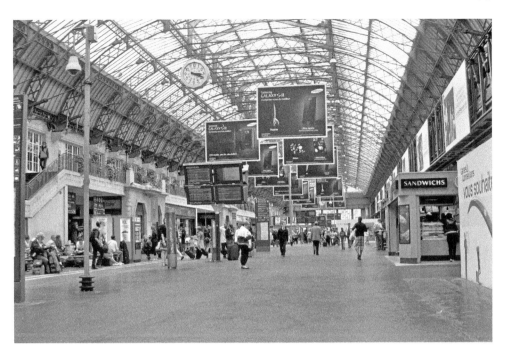

Salle de pas perdus (passenger hall). (Patrice Koch, 2011)

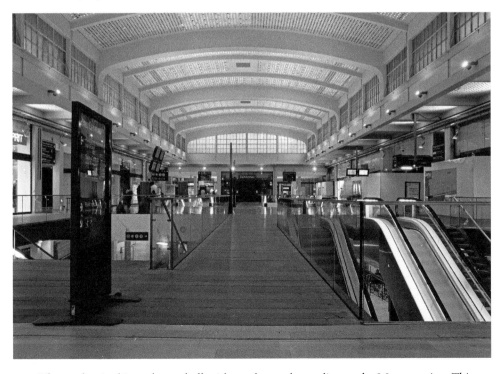

The modernised interchange hall with escalators descending to the Metro station. This art deco space was previously reserved for the handling of baggage and parcels. (Benh LIEU SONG (Own work) [CC BY-SA 3.0], via Wikimedia Commons, 2007*)

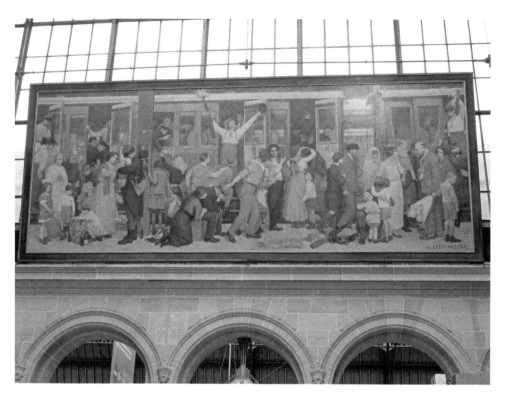

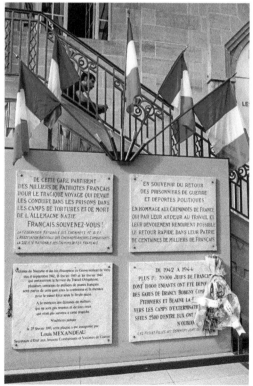

Above: This tableau in the main line passenger hall of the Gare de l'Est illustrates the departure of army reservists for the Western Front on the outbreak of the First World War in 1914. It was executed by the American painter Albert Herter in memory of his son who was killed in action in 1918. Unveiled in 1926, the mood of the painting is sombre in contrast to the high spirits of the actual event. (Colin Churcher, 2014)

Left: Plaques commemorating the deportation of French Jews and patriots from the Gare de l'Est and other stations to death camps during the Nazi occupation, as well as those sent to Germany for forced labour. One plaque recognises the efforts of French railwaymen in ensuring the rapid repatriation of survivors at the end of the Second World War. (Denis Trente-Huittessan, 2013)

The rebuilding of the station in 1926–31 introduced a number of art deco design features including this entrance from the rue d'Alsace seen at night ... (Pascal Poggi, 2008)

...as well as a new design of station clock, set here against the ironwork of the original train shed, now the passenger hall. (Leanne Lovink-Eeken, 2015)

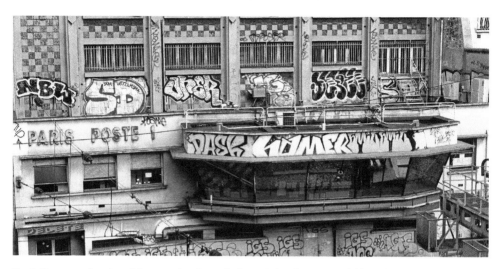

Paris Poste 1, the signal box at the Gare de l'Est. The design could best be described as functional and various artists have attempted to improve it! (Neil Delete, 2012)

A French double-deck TGV sits alongside a German ICE. (Nik Morris, 2013)

A line-up of TGVs at Paris-Est. (Oliver Aubry, 2015)

In 2010 the Gare de l'Est was twinned with Moscow's Byelorussia station to mark the introduction of an upgraded service between the two capitals, offering luxury sleeping accommodation and restaurant facilities on a journey sped up to take 39 hours. Here the Paris–Moscow train awaits departure, locomotive No. 26158 in charge of eight Russian Railways sleeping cars and a Polish Railways dining car. (Christian Torrego, 2016)

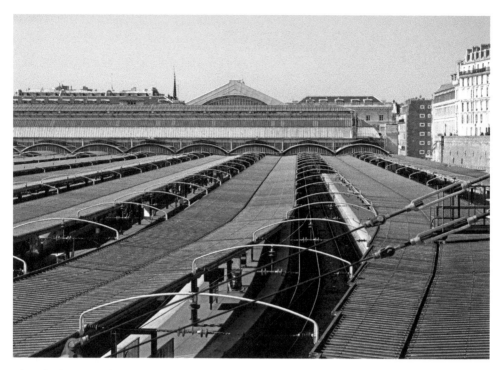

The platforms with their individual canopies curve away from the Gare de l'Est's original train shed, whose gable is visible in the background. (Pascal Poggi, 2009)

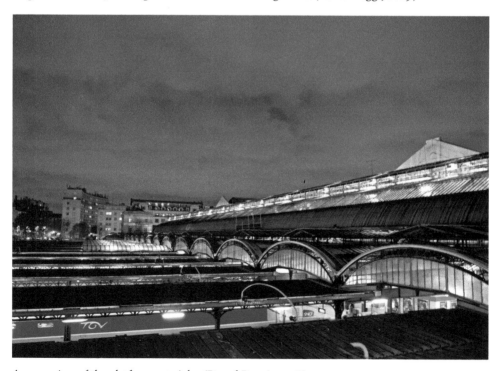

An overview of the platforms at night. (Pascal Poggi, 2008)

Gare de la Bastille

In the 1840s a new defensive ring of fortifications was built around Paris and the French government decided there was a need for a railway to link the capital with a new fortress at Vincennes. The first section of the line opened in 1853, reaching a new Paris terminus located on the Place de la Bastille in 1859.

Designed by François-Alexis Cendrier, the Gare de la Bastille (also known as the Gare de Vincennes) was primarily a local terminus for commuter traffic, but by 1889 it was handling 12 million passengers a year. In 1892 the route was extended to connect with the main line to eastern France. To cope with passenger numbers double-deck carriages known as 'Imperials' were used, these being replaced from the 1890s by another double-deck type called 'Bidels'. By the 1920s, Bastille station was handling 30 million passengers a year on seventy daily arrivals and departures.

Passenger numbers halved during the 1930s on account of the Depression and increased competition from buses and the Metro, and the service had been cut back to forty-eight trains a day by 1938. For a few months in 1945, Bastille station became the temporary Paris terminus for long-distance trains from eastern France following the wartime destruction of a viaduct on the main line serving the Gare de l'Est. After the war, carriages from German Railways were drafted in to replace the ageing Bidels and in the early 1960s these in turn were replaced by push-pull stock.

In the 1960s work began on the cross-Paris regional rapid-transit network (RER) and the first 5 kilometres of the railway to Vincennes were replaced by one of these new lines. This resulted in the closure of the Gare de la Bastille in December 1969 – the service being entirely steam-operated right up to the last day. Following closure, the station buildings became a concert and exhibition hall but, despite being listed as of historic importance, they were demolished in 1984 to make way for the Opera Bastille.

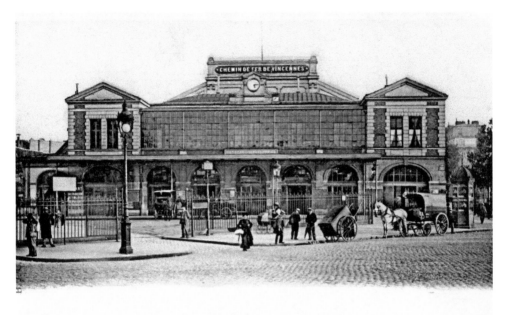

PARIS – Gare de Vincennes

Gare de Vincennes (Gare de la Bastille), around 1900. (Author's collection)

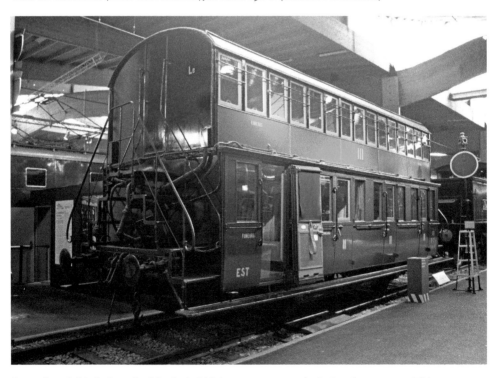

Second and third-class double-deck Bidel passenger coach dating from 1900. This type was used on the Ligne de Vincennes from the 1890s until after the Second World War. (Andrew Thirlby, 2011)

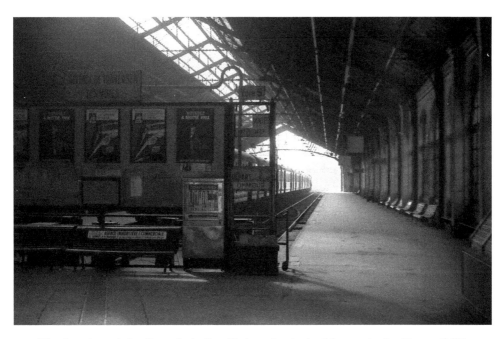

The interior of the Gare de la Bastille's train shed with a train for Verneuil-l'Etang. (Pete Hackney, 1969)

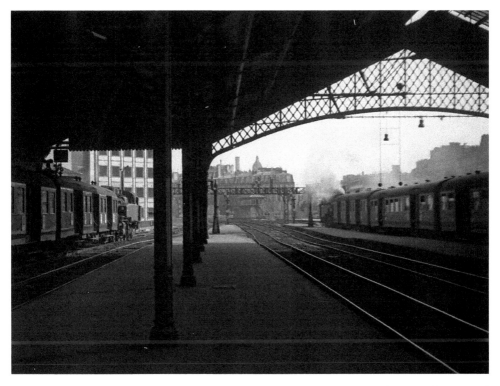

SNCF 141TBs Nos 407 and 463 wait at the head of their trains. The semaphore signal gantry over the tracks and the signal box can be seen in the distance. (Pete Hackney, 1969)

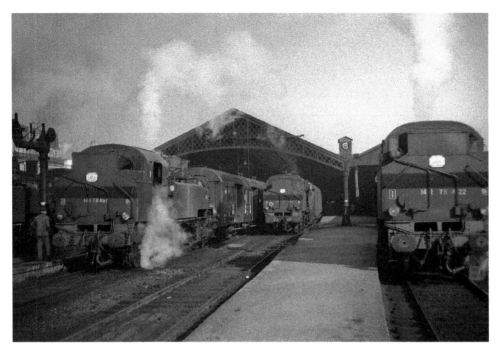

Rush hour at the Gare de la Bastille. At the country end of the station with, from left to right, locomotives Nos 497, 484 and 422 preparing to depart with their evening commuter trains. (Pete Hackney, 1969)

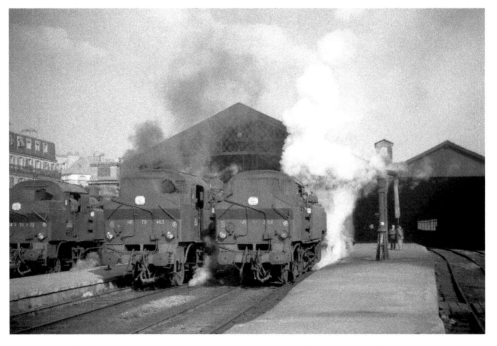

Another rush hour shot, with locomotive No. 484 departing and Nos 422 and 463 alongside. (Pete Hackney, 1969)

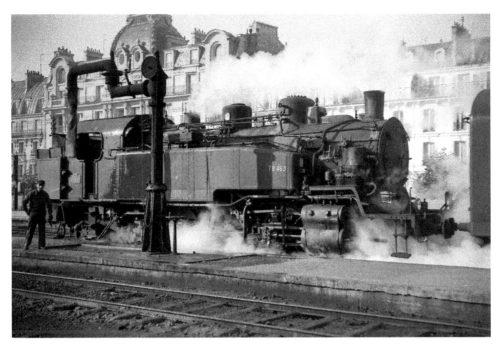

Locomotive No. 463 waits for the off... (Pete Hackney, 1969)

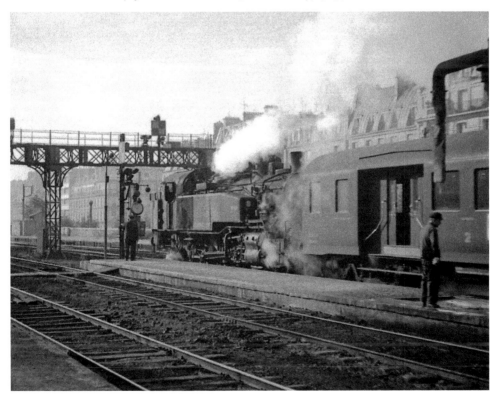

...and departs bunker-first with its train for Boissy-St Leger. (Pete Hackney, 1969)

Gare d'Orsay

The Gare d'Orsay was constructed on the site of a former palace burnt down during the Paris Commune uprising of 1871. On the left bank of the River Seine, the site was purchased by the Paris-Orléans railway company, which hoped, by extending its line from the Gare d'Austerlitz to a new city centre station on the Quai d'Orsay, to encourage the growth of commuter traffic from the suburban areas it served. The prospect of a brash new station and noisy steam trains belching smoke just across the river from the Louvre and the Tuileries provoked fierce criticism. Concerns were expressed that other railway companies would seek to follow suit to create a central railway terminus in the heart of Paris.

Such fears were to prove unfounded. The new station, originally known as the Gare d'Orléans, was the first major urban railway terminus in the world to be served entirely by electric trains. It opened in time for the Paris Exposition in 1900, at which the station itself was a principal attraction. Having changed traction from steam to electric at Austerlitz station, trains approached Orsay in a 2-mile-long tunnel under the banks of the Seine.

Designed by Victor Laloux, the Gare d'Orsay was monumental in scale. Laloux was very conscious of the need to match the requirements of a modern station with its architectural setting and so ensured that the elevation fronting the river was sufficiently impressive to be worthy of its historic surroundings. Although appearing to be built of solid stone blocks, in reality these are suspended from a steel frame. At each end of the Seine frontage is a giant pavilion with an outsize illuminated clock. Between the pavilions are seven glazed arches, above which are carved the Paris-Orléans company's initials and the names of the principal stations served by the railway. Surmounting all this are three giant statues representing Bordeaux, Toulouse and Nantes, while the slate mansard roofline is topped off with an obelisk and finials. In all, the façade facing the river is an exuberant expression of the Beaux-Arts style.

The absence of steam locomotives did away with the need for a conventional iron train shed. There were three main internal spaces: a barrel-vaulted entrance arcade, the booking hall and the glazed train shed. The overall effect was to produce a single space topped by a graceful vault with skylights, the walls and roof appearing to form

a continuous arch. Originally it was possible to look down from the concourse to the platforms below but these were later roofed over to increase the ground-floor circulating area. A giant fanlight at one end of the train shed housed what was possibly the most ornate clock at any European railway station. Special conveyor belts, lifts and ramps were installed to ensure that the movement of luggage was kept separate from the passenger circulating areas. The Gare d'Orsay was widely acclaimed and had a major influence on the design of later stations in Copenhagen, Hamburg and New York.

Being so close to the river, the Gare d'Orsay was in constant danger of flooding. In 1910 it was badly affected in the Great Flood of Paris when the platforms below ground level were inundated to a depth of several metres. Other shortcomings were becoming evident as early as the 1920s, particularly the short platforms which could not accommodate the longer trains being brought into use. In 1939 the decision was taken to terminate all main-line trains at the Gare d'Austerlitz once more, leaving only a shuttle service to a new underground platform at Orsay. The main station was closed and abandoned after less than forty years' service. During the Second World War the former station was used as a collection point for the dispatch of parcels to prisoners of war, and after the war as a reception centre for liberated prisoners and deportees on their return.

By the 1960s, architectural opinion had moved on and the Gare d'Orsay was derided for the very aspects that had drawn acclaim sixty years before. The Beaux-Arts style was anathema to modern concepts of architecture and Laloux's successful attempts to soften the harsh functional aspects of an electrified railway terminus with lavish detailing and traditional materials now brought only condemnation. Several proposals were made to tear the building down and replace it with something unashamedly modern but the plans came to nothing. In 1971 the Minister of Cultural Affairs stepped in at the eleventh hour to halt plans for the construction of a massive new hotel on the site. Two years later the President of the Republic intervened to give the Gare d'Orsay statutory protection and it was subsequently decided to convert the station into a museum of French art. With the exhibition spaces inserted into the shell of Laloux's train shed, the building re-opened as the Musée d'Orsay in 1986, the huge station clock still dominating the museum's main hall. Today the Musée d'Orsay is served by a stop on Line C of the RER network.

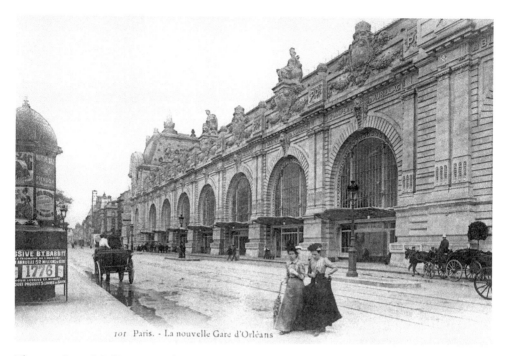

101 Paris. - La nouvelle Gare d'Orléans

The new Gare d'Orléans around 1900. This was the original name of the station that later became the Gare d'Orsay.

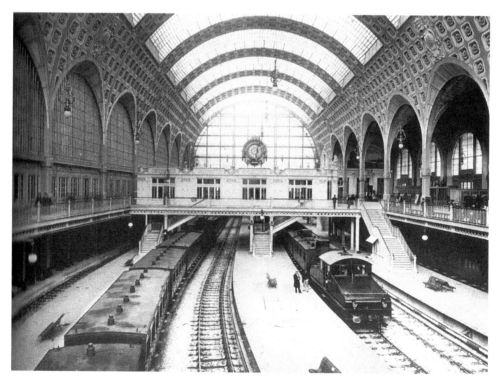

Inside the new Gare d'Orléans around 1900.

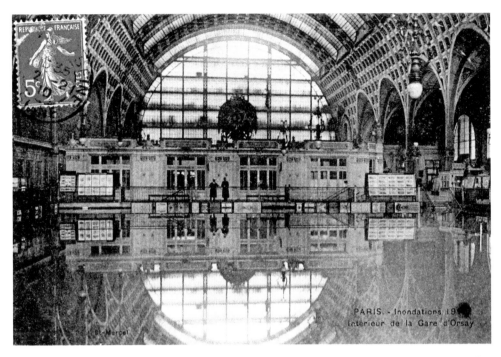

Postcard showing the tracks flooded to a depth of several metres in 1910. The card is postmarked February 1910, when much of Paris was still under water – quick work by the postcard manufacturers. The handwritten message on the back reads '*Bons souvenirs!*' ('Happy memories'). (Author's collection)

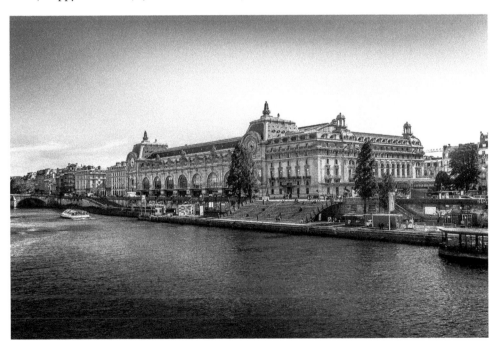

Gare d'Orsay seen from the Seine. (S. Barry Lubman, 2015)

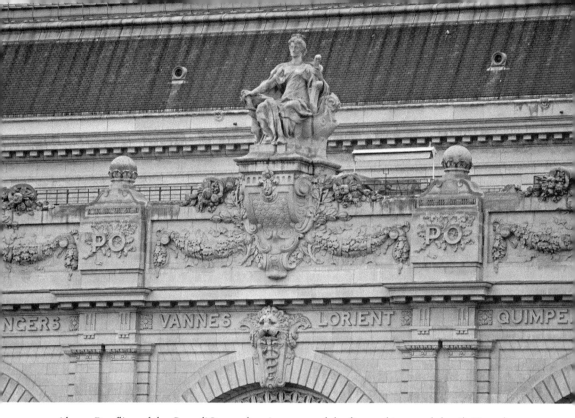

Above: Roofline of the Gare d'Orsay showing some of the fine architectural detail. (Pascal Poggi, 2009)

Below: The clock on one of the pavilions of Orsay's façade. (Pascal Poggi, 2013)

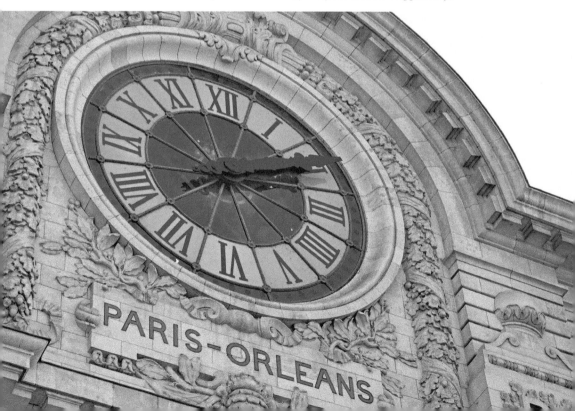

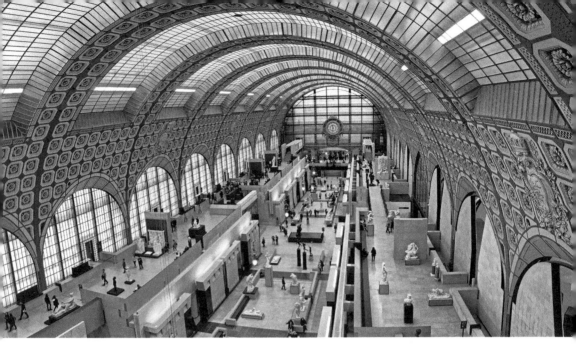

Above: The spectacular interior of the Musée d'Orsay, formerly the Gare d'Orsay. (Bert Kaufmann, 2016)

Right: Possibly the most ornate station clock in the world, still keeping time in the Orsay Museum. (Pete Hackney, 2008)

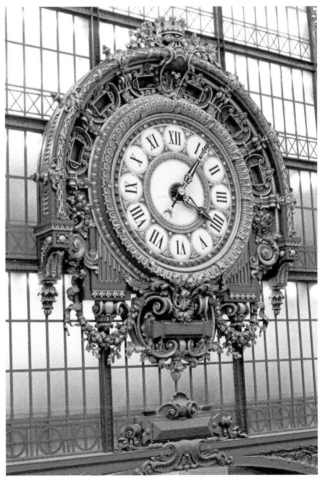

Gare de Bercy

The Gare de Bercy opened in the 1970s on the site of a large former goods station, once the main arrival point and distribution centre for wine in Paris. It serves part of the same rail network as the nearby Gare de Lyon, for which in effect it operates as an annexe. The station specialises in AutoTrains, which transport travellers' cars or motorbikes overnight to or from a range of places in southern France including Avignon, Biarritz, Bordeaux, Lyon, Marseille, Narbonne, Nice, Toulon and Toulouse. Vehicle owners used to be able to travel in couchette accommodation on the same train but now have to travel to their destination separately.

In 2002 the Gare de Bercy was renovated to accommodate the overnight sleeper trains between Paris and some of Italy's principal cities, including Rome, Florence, Bologna, Venice and Milan. These trains had previously operated from the Gare de Lyon, which no longer had sufficient capacity to deal with them. However, a much reduced sleeper operation reverted to the Gare de Lyon in 2011, depriving Bercy of its short-lived status as an international station.

The proposed transfer to Bercy of Intercity trains from the Auvergne region in 2011 caused considerable controversy as it was argued, not without cause, that Bercy did not have the same facilities or status as the Gare de Lyon and that services from the Auvergne were effectively being downgraded. For example, catering outlets at Bercy are limited to snacks and drinks. However, pressure on capacity at the Gare de Lyon as a result of additional TGV trains eventually made the transfer of the Auvergne services inevitable. Following this change, passenger numbers rose to 13,200 a day with fifty-nine trains using the station.

Bercy continues to relieve pressure on the Gare de Lyon by acting as the Paris terminus for some medium-distance domestic services, including Intercity trains to Montargis, Nevers and Clermont-Ferrand as well as some regional services to Burgundy under the branding 'TER Bourgogne'. In recognition of its growing role, the station was renamed 'Gare de Paris-Bercy-Bourgogne-Pays d'Auvergne' in September 2016, giving the smallest of the Paris termini by far the longest name.

Gare de Bercy. (Mbzt (Own work) [CC BY-SA 4.0], via Wikimedia Commons, 2015*)

Station reception desk. (Jean-Louis Zimmermann, 2011)

Concourse at Gare de Bercy. (Jean-Louis Zimmermann, 2011)

Locomotive No. BB22251 heads a train of car-carriers from Paris-Bercy. (Oliver Aubry, 2015)

Locomotive No. BB22269 on a train of Rhone-Alpes rolling stock from Lyon. (Chris Gibbs, 2013)

An Intercity train just arrived from Clermont-Ferrand. (Colin Churcher, 2012)

Acknowledgements

I would like to thank the following people for permission to use their copyright photographs in this book: Oliver Aubry, Stéphanie Benjamin, Xavier Briand, Anurag Chalmers, Colin Churcher, Philippe Clabots, John Cosford, Sébastien Couradin, Doods Damaguing, Neil Delete, Didier Duforest, Bernard Fourmond, Haniel Francesca, Thangasivam Gandhi, Chris Gibbs, Pete Hackney, Marc Heurtaut, Bert Kaufmann, Stewart Leiwakabessy, Patrice Koch, Yann Kopf, Jorge Láscar, Leanne Lovink-Eeken, S. Barry Lubman, Mattéo Mechekour, Michel Mensler, Leen Molema, Nik Morris, Sébastien Nguyen van Tam, Rob Nopola, Nic Oatridge, Miroslav Pejic, Pascal Poggi, Jean Rachez, Mark Rijs, Chris Sampson, Mike Smee, Andrew Thirlby, Christian Torrego, Denis Trente-Huittessan, Benoit Wittamer and Jean-Louis Zimmermann. I am also grateful to Vladimir Tkalčić for allowing me to use an image of the 1895 Montparnasse train crash from his collection.

I have used some images under the terms of Creative Commons licences. These are denoted by an asterisk (*) next to the name of the photographer or image owner (some of whom are identified only by a pseudonym) namely: Vincent Babilotte, 'Mbzt', 'Pascal 3012', 'Sémhur', Claude Shoshany, Benh Lieu Song and 'Velvet'.

All images in this book remain the copyright of their photographer or owner.

The facts and figures in this book have been drawn from numerous sources that I have attempted to verify as far as possible. Every attempt has been made to seek permission for copyright material used in this book. However, if we have inadvertently used copyright material without permission or acknowledgement we apologise and we will make the necessary correction at the first opportunity.